ORIGAMI

The Art of Paper Folding

ROBERT HARBIN

FUNK & WAGNALLS

To Neal Elias and Fred Rohm

Originally published by The English Universities Press, Ltd.
under the title TEACH YOURSELF ORIGAMI
First American edition published in 1969
by arrangement with The English Universities Press, Ltd.
Funk & Wagnalls Publishing Company, Inc.
ISBN 0-308-90099-5

PRINTED IN THE UNITED STATES OF AMERICA

PREFACE

Writing a book, whatever the subject, is always a laborious task for me. But writing this one has been a real pleasure, because I am anxious to introduce as many as possible to this new world of Origami which has given me so much enjoyment.

The main task has been to design the illustrations, because without them there could not be a book. Diagrams take a long time to prepare because, fold by fold, the three-dimensional paper model must be reduced to a two-dimensional drawing on a flat sheet of paper. And the drawing must be clear and accurate if the student is to understand how to produce the finished model from it.

It could be argued, I suppose, that Origami has an end product that is not worth keeping. Nothing could be further from the truth. At the time of writing, I have a delightful collection of the world's best paper folds, carefully stored in transparent envelopes, which are in turn mounted on a sheet of black board. This way, they are ready to be produced and shown quickly—and they *are* produced and shown, at the slightest provocation!

If this art form captures you, as it has certainly captured me and many others, you will discover that it brings with it a new dimension in enjoyment, which is infinite in its variety and unrivalled in its capacity to make you relax and forget everything else.

London ROBERT HARBIN

v

CONTENTS

A SHORT HISTORY
OF ORIGAMI

'Origami' (pronounced *or-i-gäm'ē*) is a Japanese word which means paper-folding. The Japanese do not consider Origami to be an art form, but look on it rather as something which is an integral part of their culture.

Associated in the first instance with the making of intricate paper dolls, the designing of *Noshis* (folded tokens) and of attractive packaging, Origami has now become an accepted pastime for the young and an intellectual hobby for many adults.

In Japan, two great names dominate the Origami scene: Akira Yoshizawa and Okimasa Uchiyama. The genius of Yoshizawa has influenced most Japanese and Western folders.

Because of the sudden interest the West has shown in Origami, Japanese publishers have been quick to produce a flood of attractive books on the art, written in Japanese and English, and many of them containing complete finished models pasted into the books themselves.

Although these Japanese books are a delight to look at, they fail in the object of teaching. Westerners do not easily follow diagrams, and the Japanese wrongly assume that their explanations are sufficient instruction for the beginner.

Peter Van Note, of New York, who is a keen paper-folder, has carried out some research on the origins of Origami, and has the following observations to make: 'I recently acquired, by pure chance, a Japanese manuscript describing paper-folding according to the ancient practices. It was published about the same time as the Kan No Mado manuscript, but I have reason to believe that it illustrates the paper-folding of Japan's Heian Period (A.D. 782–1185).

'If this is proven true (and I believe it can be), then we

have the earliest examples of paper-folding on record—
about 1,000 years old.

'In the Japanese way of figuring time, the aforementioned
manuscript dates back to the middle of the Edo Period,
which lasted from about the time England's Henry Hudson
was sailing up the Hudson River (1607–1611) to shortly
after the American Civil War (1865).

'For what it is worth, here is a thumbnail outline of the
history of Origami:

Elaborate ceremonial paper-folding and simple "re-
creational" paper-folding—Heian Period.

Water Bomb Base: probably used in the Heian Period
for making ceremonial paper butterfly figures.

Crane Base (Bird Base): Edo Period, probably 1700's
to mid-1800's.

Frog Base: Late Edo Period, probably not before the
1800's.

'The above conclusions must necessarily be tentative, but
they are based on good evidence. It should be noted that
the Heian and Edo Periods were times of peace and leisure
in Japanese history, while the intervening four centuries
were characterised by instability and bloody battle.'

Thank you, Peter Van Note!

The Spanish have been great paper-folders for many
years, and the best Western results have emerged from
Spain and the Argentine. You should watch out for names
like Vicente Solorzano, Ligia Montoya, N. Doctor Montero,
and many more. The Spanish have a style of their own, of
which the Praying Moor figure (included in this book) is a
fine example.

In Great Britain, things are beginning to happen these
days, and some fine originals are appearing. Look out for
names like Eric Kenneway, Iris Walker, and Trevor
Hatchett and Tim Ward, two brilliant young men from
Oxford University. These two enthusiasts are busily pre-
paring a book about their own creations which they hope to
have published in the near future.

By far the most exciting results are coming from America, and you will come across names like Fred Rohm, Neal Elias, Robert Neale, George Rhoads, Jack Skillman, and many others, both male and female. Many books would need to be written to keep pace with the flood of originals coming from this source.

Mrs. Lillian Oppenheimer, of New York, has devoted a great part of her life to stimulating interest in Origami, and to this end she runs an Origami Centre in New York, and is the publisher of *The Origamian*, which keeps the dedicated enthusiasts in touch with current Origami happenings.

I am happy to include in this book several originals by contemporary folders from many countries, and to them I tender my grateful thanks.

THE ESSENTIALS
OF ORIGAMI

It is a fact that most beginners are not able to follow diagrams and instructions easily and successfully, however carefully they may have been planned. As a rule, Origami illustrators try to cram into each page as much information as possible. This practice is welcomed by the enthusiast and the expert, because it means that the book will be able to explain a large number of models. Unfortunately, though, a page filled with diagrams completely bewilders most beginners.

I have borne this in mind while preparing this book, and you will notice that the earlier pages have been designed with no more than two or three diagrams per page. All the diagrams are clearly drawn, and contain helpful instructions and symbols to give you all possible help, and to explain the mainly standard models which bring you in touch with most of the Basic Folds.

A Basic Fold is a fold from which many models can be made. There are many Basic Folds, both ancient and modern, but this book will introduce you to just enough to give you a good groundwork on which to begin.

Look at the first fold illustrated in the book, and notice how the instructions are placed on the parts to be folded: FOLD THIS SIDE DOWN, and then TO HERE, and so on. The instructions are made to work for you. Later in the book, the instructions are placed alongside the diagrams, and not on them, because it is assumed that by then you will have become familiar with the different processes.

Always fold carefully, accurately, and neatly. If you fold carelessly, the result will be disastrous.

4

Study each diagram showing the complete folded model. Then, and only then, place your Origami paper in front of you and make your first fold.

When you make a fold, always crease the paper firmly with the back of your thumbnail. Good creases make folding easy, and are an invaluable guide later in the model, when you are making a series of folds.

Pre-creasing is an important feature. Consider, for example, the Japanese Lady. This model was sent to Samuel Randlett, who immediately used the idea to produce his fine Fish. Notice how he pre-creases the paper he uses so that everything folds into place at the right moment.

Before you make a Reverse Fold, pre-crease the paper by folding the whole thickness before opening the paper and making the fold (see Reverse Folds).

Notice how paper coloured on one side is used to get the maximum effect for each model. The subject of paper is an important one. Origami paper (which is available from a variety of sources, some of which I have listed at the end of this book) should be strong, thin, and suitably coloured. But if you cannot lay hands on special Origami paper, almost any paper may be used.

If you are instructed to use a square of paper, make sure that it really is square, and that a rectangle is a true rectangle. Most of the models in this book are based on squares of paper, but there is no regular rule about this, as all shapes of paper can be used, according to the model's needs. See, for example, the Ornithonimus and Aladdin's Lamp.

Origami is not meant to be a simple art. To the expert, it is a challenge to the eye, the brain, and the fingers, a wonderful mental and physical therapy.

When you fold one of the decorations explained in this book, you will find that by altering this or that fold you can invent endless shapes. In fact, you can doodle for hours.

When you have mastered the Basic Folds, you will then be equipped to produce figures and shapes of your own. Have something in mind, and then consider the best Base from which to start. You will notice that there are three different ways in which to make a Penguin. The Penguin

seems to be a favourite subject, and almost every folder has had a go at it.

Watch out for terms like Squash Fold. It is so named because you do just that—squash the part indicated so that the sides bulge and it flattens, in most cases symmetrically.

Study the Petal Folds, the Rabbit's Ears, and the various Bases, and try to remember what they are. If you get stuck, have a look at the Contents and refer to the page or pages concerned.

You will notice that certain procedures are used over and over again. You will soon get used to these and be able to carry them out automatically.

When you have folded everything in the first half of the book, you will find that more and more diagrams begin to appear on each page, and that the symbols begin to play a bigger part than the instructions. Decoration 2 has been included as an exercise so try to make this up using the symbols only.

Start at the beginning of the book and work your way slowly and steadily through. Do not attempt anything too difficult, to start with, because this can only end in disappointment.

If you are making a long train journey, take this book with you and fold a piece of paper to pass the time during your journey. Find a friend with the same interest, and you will both pass many a happy hour.

For the rehabilitation of damaged hands there is nothing like Origami for making reluctant fingers come back to life.

Finally—take it slowly; fold carefully, neatly and accurately. And START AT THE BEGINNING.

A Note on
SYMBOLS

The symbols used in this book are based on Akira Yoshizawa's code of lines and arrows. Symbols must become second nature to you when folding, but you will find that they are easy to acquire.

The moment you see a line of dashes, you know that the paper must be Valley Folded along that line. When you see a line of dashes and dots, you recognise the sign for a Mountain Fold. To make a Mountain Fold, you naturally turn the paper upside down and make a Valley Fold.

Arrows show the directions in which you must fold: left, right, up, down, in front, behind, and into.

You will notice one arrow which shows that a drawing has been enlarged for clarity. Another arrow indicates that a model must be opened out (see Samuel Randlett's Fish). My own special little black arrow indicates that you must sink, press, squeeze, or push in at certain points.

The symbols are in fact self-explanatory. They are simple common sense, and can be learnt in about ten minutes.

Try to use the symbols only and ignore explanations. This will help you when you come to read Japanese Origami books.

INTERNATIONAL ORIGAMI SYMBOLS

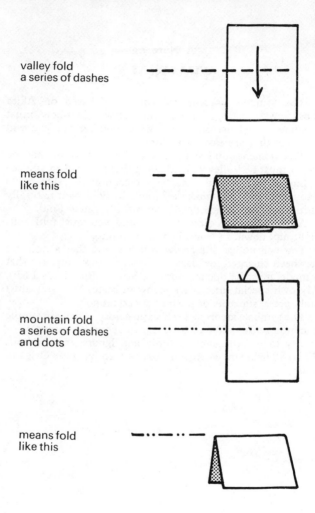

valley fold
a series of dashes

means fold
like this

mountain fold
a series of dashes
and dots

means fold
like this

if a drawing
was marked
with these symbols

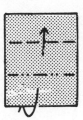

the result
should be
this

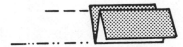

when a drawing
is followed by
this little looped
arrow

turn the
model over
so

this black arrow

means push in

thin lines mean creases

this symbol

means

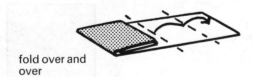

fold over and
over

MAKE THIS WATER BOMB BASE AND PRELIMINARY FOLD

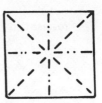

if a drawing is
marked like this

you make this
water bomb base

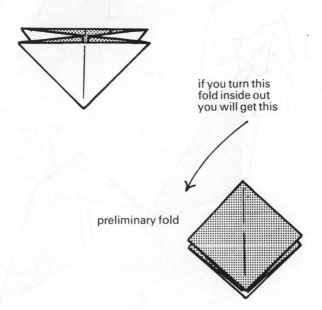

if you turn this
fold inside out
you will get this

preliminary fold

reverse fold 1

crease

note how paper is
marked. crease
along the mark.
now reverse fold
as shown

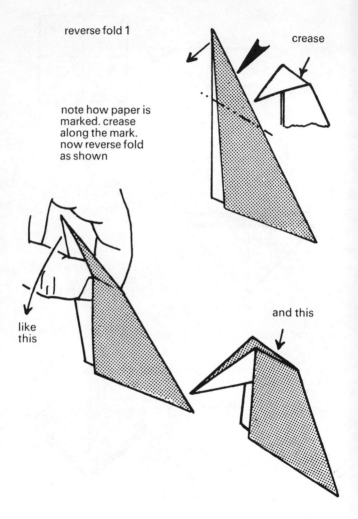

like
this

and this

reverse fold 2

crease

note how paper is
marked. crease
along the mark.
now reverse fold
as shown

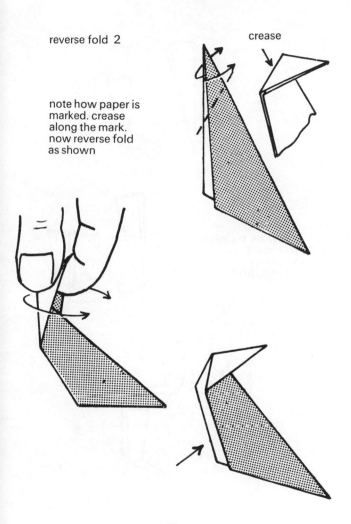

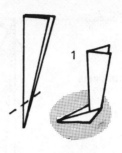

1

how to fold feet.
(birds, animals, people.)
1. reverse fold 2
2. reverse fold 1
3. two reverse folds

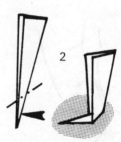

2

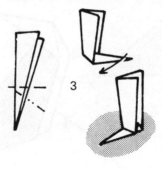

3

HOW TO MAKE A BIRD'S HEAD

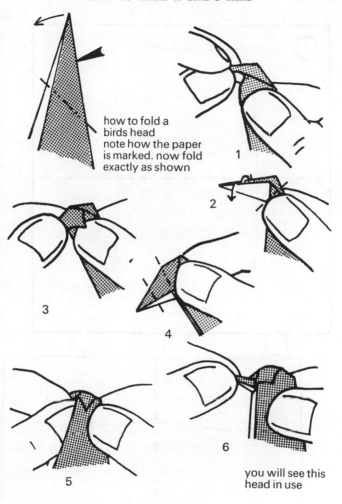

how to fold a
birds head
note how the paper
is marked. now fold
exactly as shown

1

2

3

4

5

6

you will see this
head in use

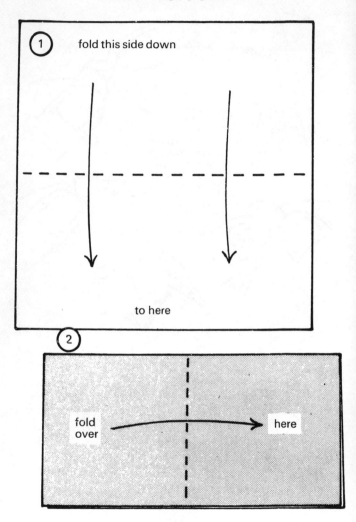

③ back to here ← unfold

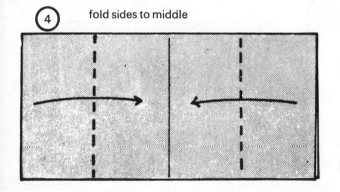

④ fold sides to middle

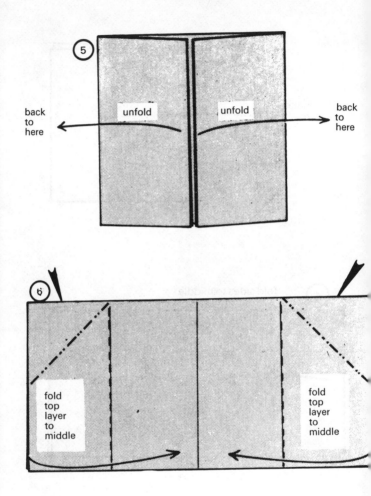

⑤ back to here ← unfold unfold → back to here

⑥ fold top layer to middle fold top layer to middle

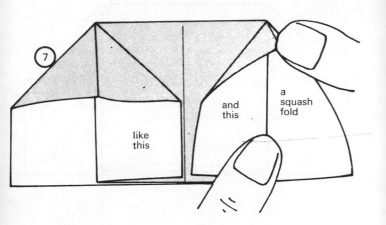

like
this

and
this

a
squash
fold

now draw doors and windows

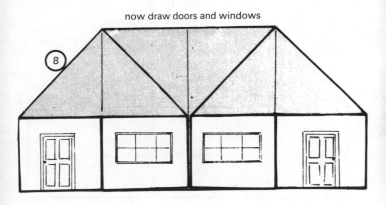

19

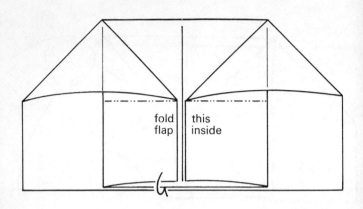

fold
flap

this
inside

now –
turn the
model over

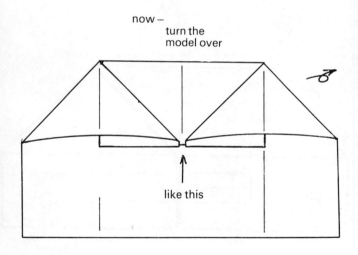

like this

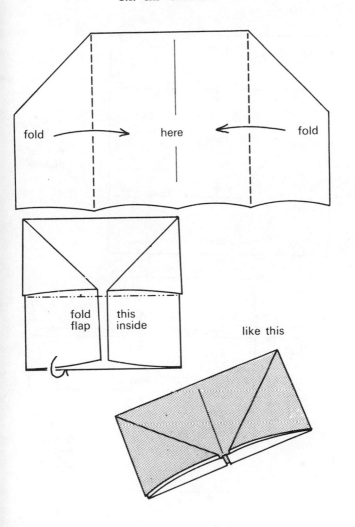

fold ⟶ here ⟵ fold

fold flap this inside

like this

BOAT *Use a square of paper*

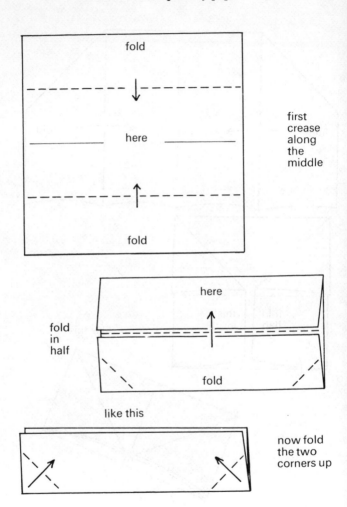

fold

↓

here

fold

first
crease
along
the
middle

fold
in
half

here
↑

fold

like this

now fold
the two
corners up

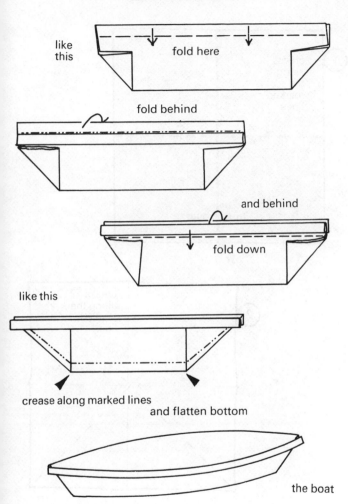

like
this

fold here

fold behind

and behind

fold down

like this

crease along marked lines

and flatten bottom

the boat

23

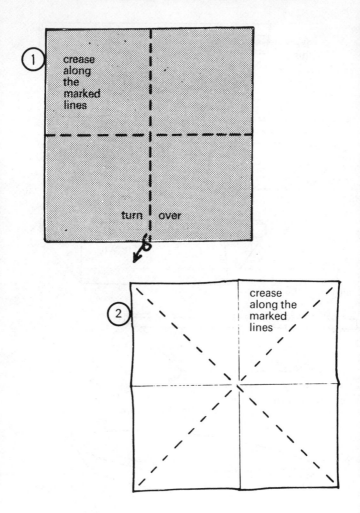

(1) crease along the marked lines

turn over

(2) crease along the marked lines

24

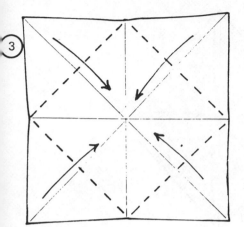

now fold the corners in

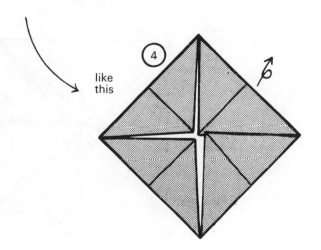

like
this

25

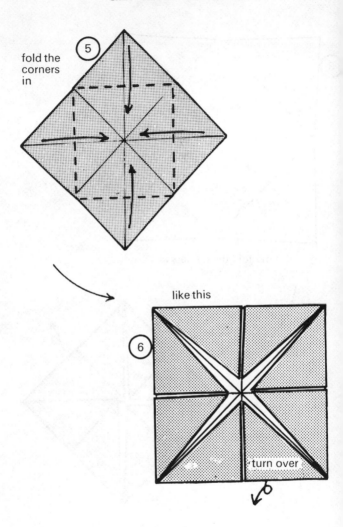

fold the corners in

⑤

like this

⑥

turn over

26

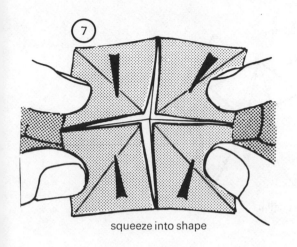

⑦

squeeze into shape

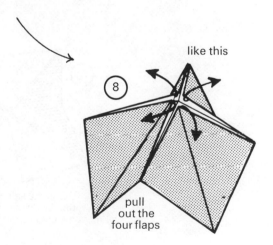

⑧

like this

pull
out the
four flaps

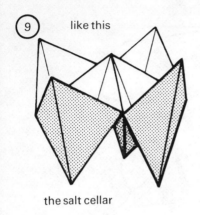

⑨ like this

the salt cellar

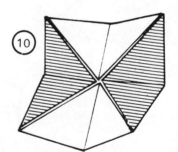

⑩ this is the salt cellar
upside down. colour
the areas shown

28

to make
the colour
changer

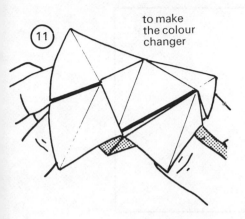

and this
shows how you
make it work

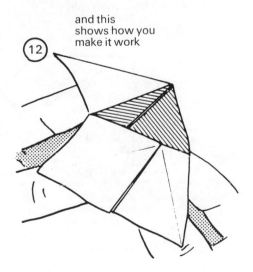

29

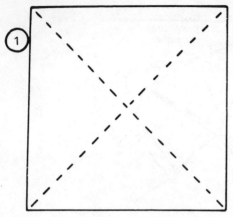

crease along the marked lines

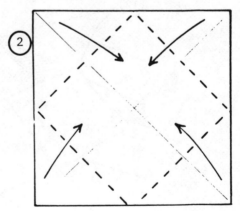

fold the four corners to the centre

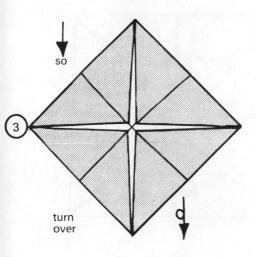

so

③

turn
over

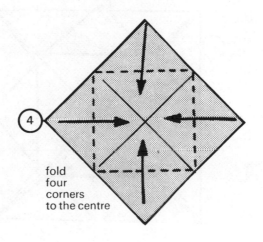

④

fold
four
corners
to the centre

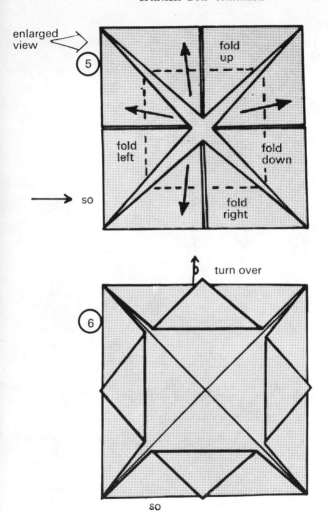

32

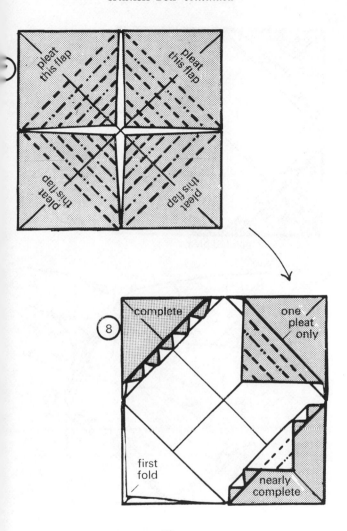

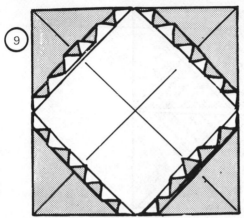

completed pleats

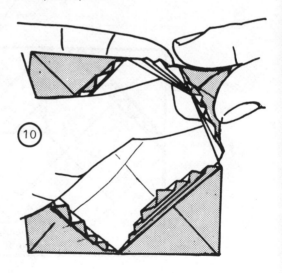

push left thumb into each
corner and press together
on the outside until the
fancy box is completed

so

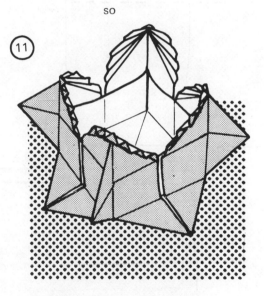

fill the box with sweets

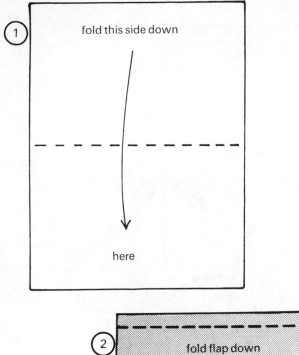

① fold this side down

here

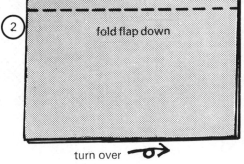

② fold flap down

turn over

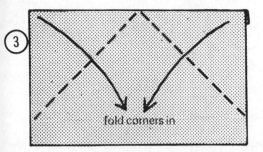

fold corners in

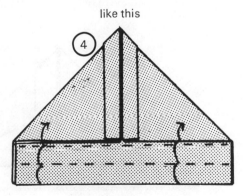

like this

fold this flap over
twice

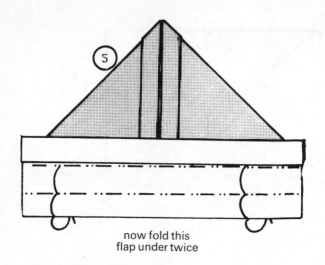

now fold this
flap under twice

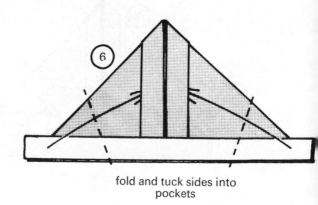

fold and tuck sides into
pockets

38

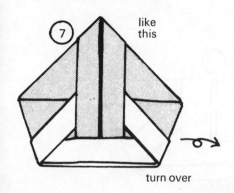

⑦ like this

turn over

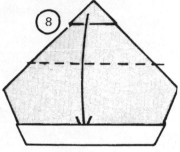

⑧

fold down top
and tuck into
pocket

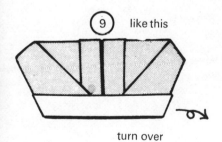

⑨ like this

turn over

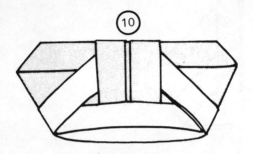

the turban complete

try this with
a sheet of
newspaper

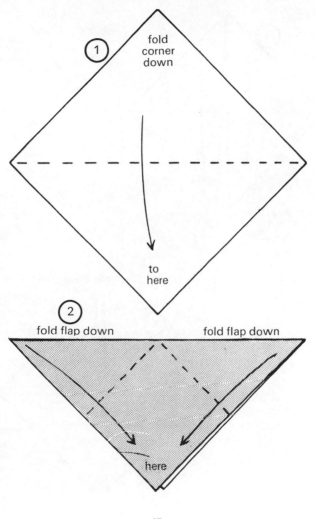

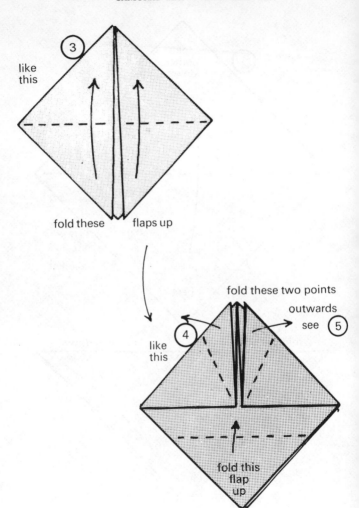

③ like this

fold these / flaps up

④ like this

fold these two points

outwards see ⑤

fold this flap up

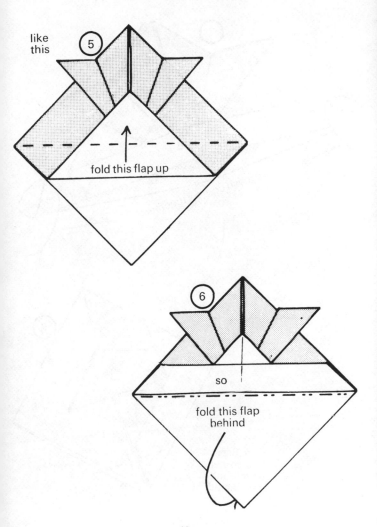

like
this

⑤

fold this flap up

⑥

so

fold this flap
behind

43

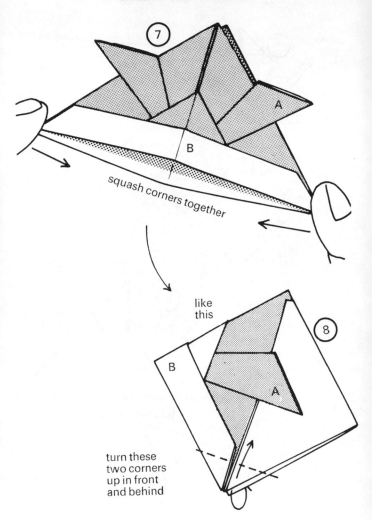

⑦

A

B

squash corners together

like
this

⑧

B

A

turn these
two corners
up in front
and behind

44

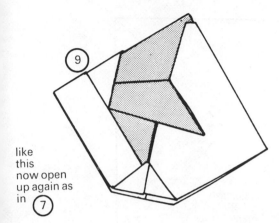

9

like
this
now open
up again as
in 7

a piece of paper
20 inches square
will make a hat
to fit your head

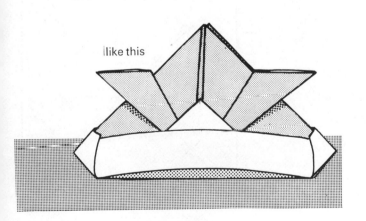

like this

45

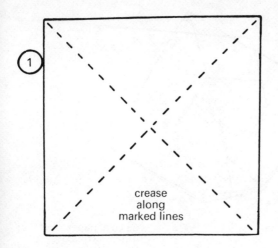

① crease
along
marked lines

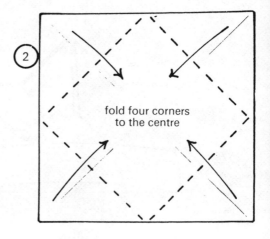

② fold four corners
to the centre

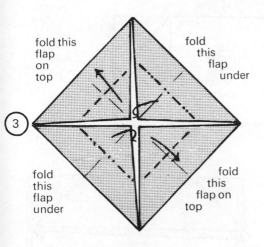

fold this flap on top

fold this flap under

③

fold this flap under

fold this flap on top

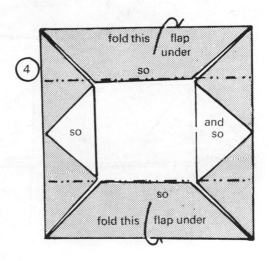

④

fold this flap under

so

so

and so

so

fold this flap under

47

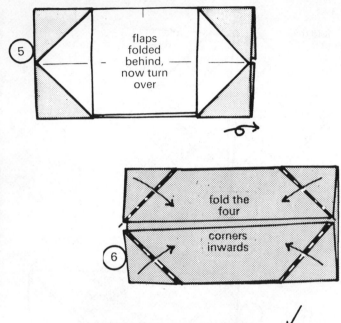

⑤ flaps folded behind, now turn over

⑥ fold the four corners inwards

so

⑦ fold the four corner flaps inwards

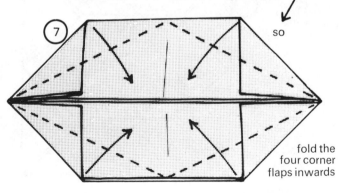

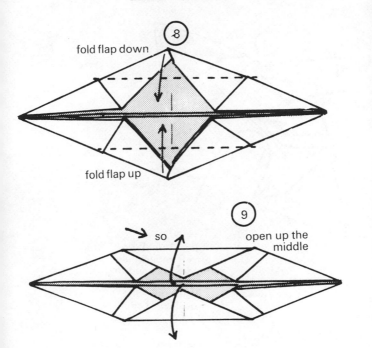

fold flap down

⑧

fold flap up

⑨

so

open up the middle

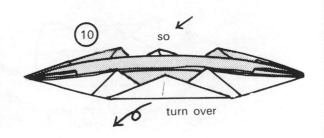

⑩

so

turn over

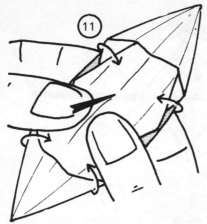

(11)

press thumbs in, then
with fingers pull
sides up – and so
turn the boat
inside out – the
result will be
this

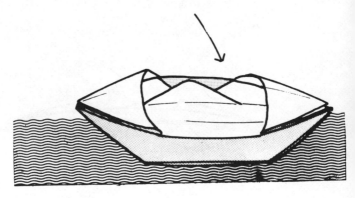

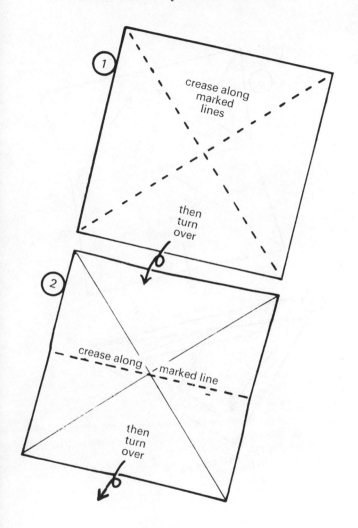

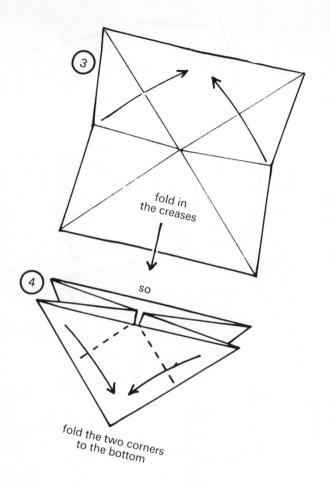

③ fold in
the creases

so

④ fold the two corners
to the bottom

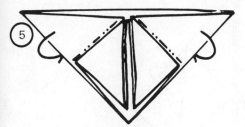

fold the two corners behind

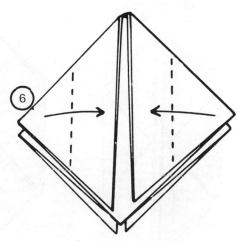

fold the two flaps
to the centre

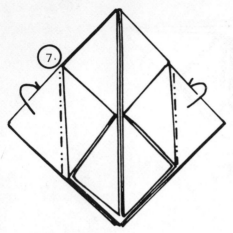

fold the two
flaps behind

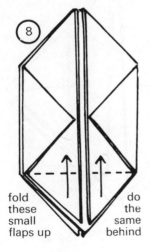

fold
these
small
flaps up

do
the
same
behind

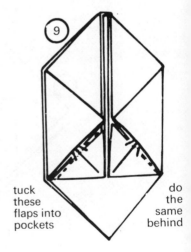

tuck
these
flaps into
pockets

do
the
same
behind

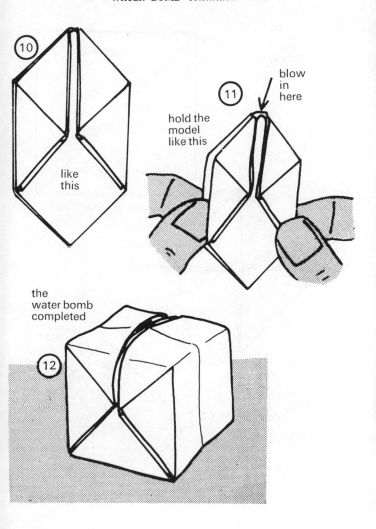

(10) like this

(11) hold the model like this

blow in here

(12) the water bomb completed

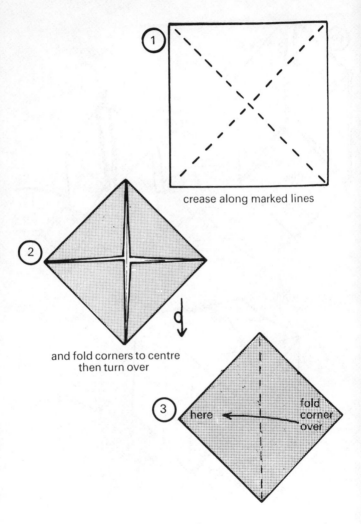

① crease along marked lines

② and fold corners to centre
then turn over

③ fold corner over

here

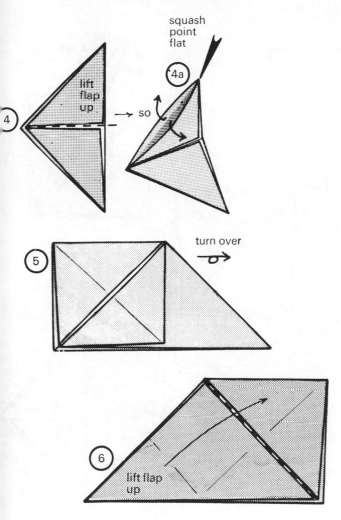

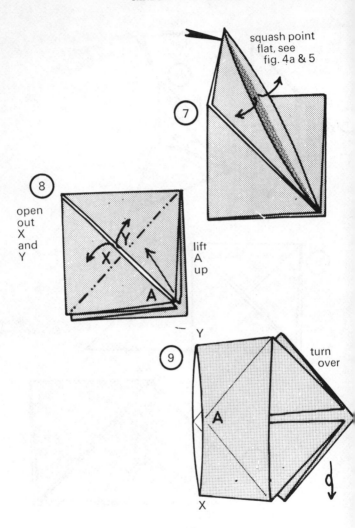

squash point flat, see fig. 4a & 5

⑦

⑧

open out X and Y

lift A up

⑨

turn over

58

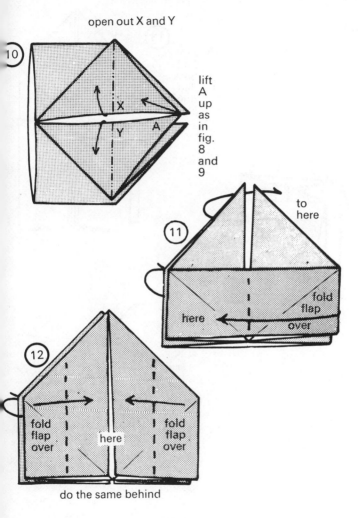

open out X and Y

lift A up as in fig. 8 and 9

to here

fold flap over

here

fold flap over

here

fold flap over

do the same behind

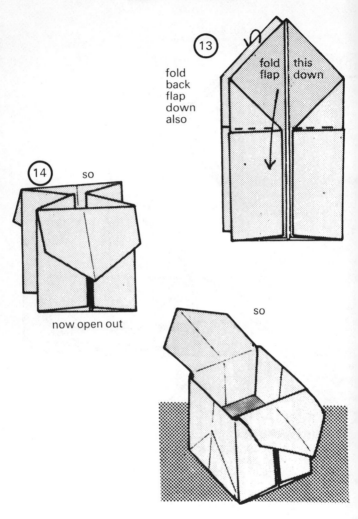

(13)

fold
back
flap
down
also

fold
flap

this
down

(14)

so

now open out

so

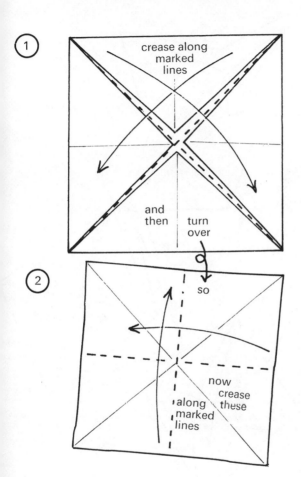

① crease along
marked
lines

and
then | turn
over

② so

now
crease
these
along
marked
lines

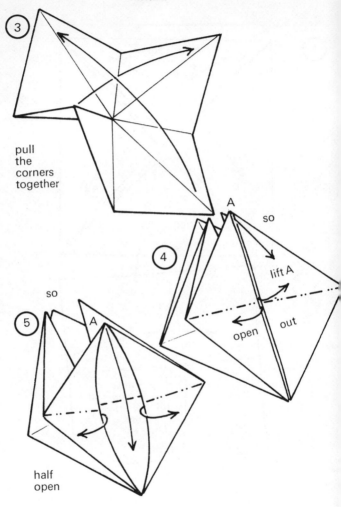

③ pull the corners together

④ so lift A out open

⑤ so A half open

62

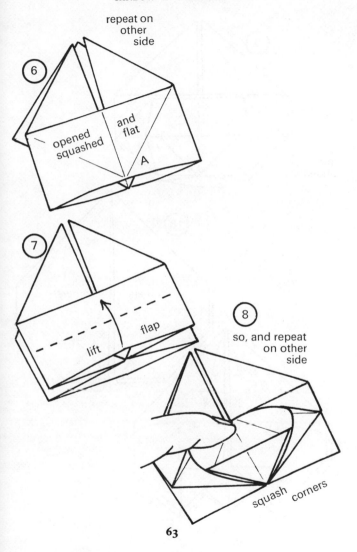

repeat on other side

⑥

opened squashed

and flat

A

⑦

lift

flap

⑧

so, and repeat on other side

squash corners

63

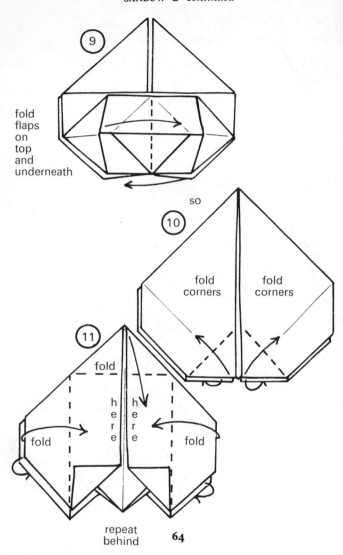

(9) fold flaps on top and underneath

so

(10) fold corners fold corners

(11) fold h e r e h e r e fold

fold fold

repeat behind

64

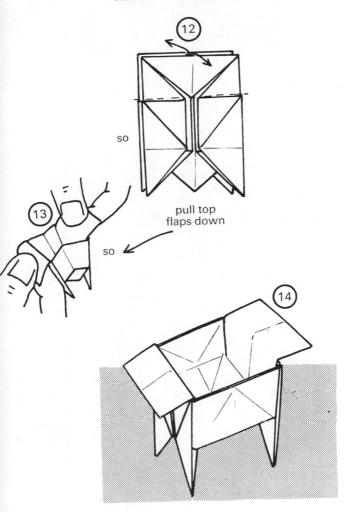

12

so

pull top
flaps down

13

so

14

65

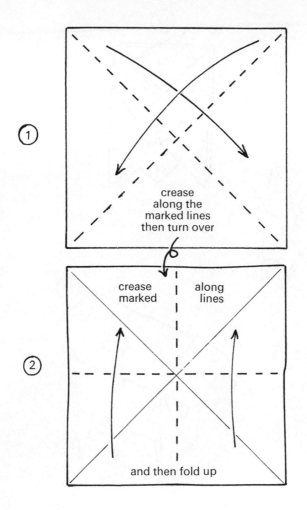

① crease
along the
marked lines
then turn over

② crease marked along lines

and then fold up

so

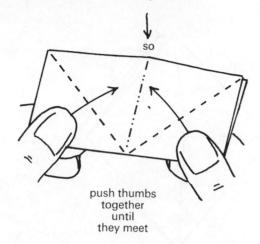

(3)

push thumbs
together
until
they meet

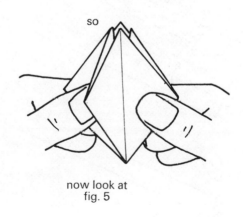

(4)

so

now look at
fig. 5

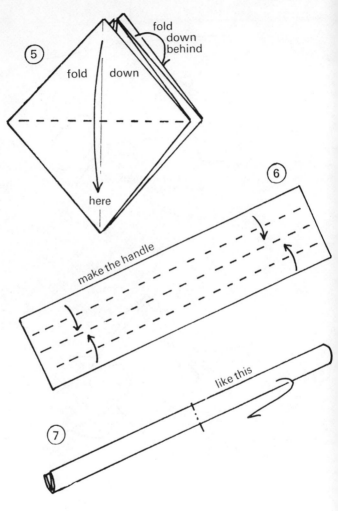

fold
down
behind

⑤

fold down

here

⑥

make the handle

like this

⑦

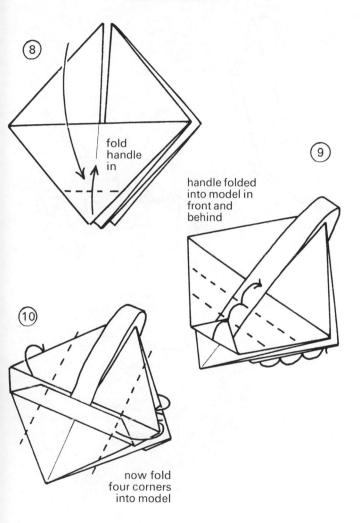

⑧ fold handle in

⑨ handle folded into model in front and behind

⑩ now fold four corners into model

69

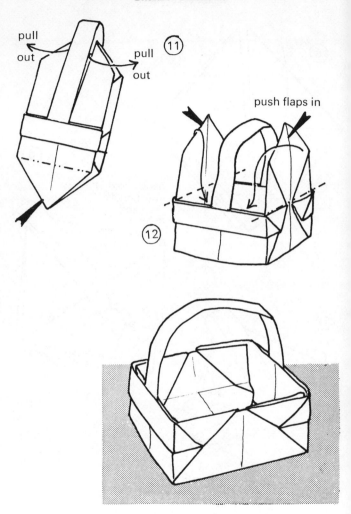

pull out

pull out

(11)

push flaps in

(12)

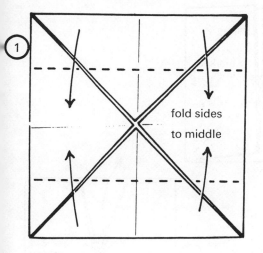

fold sides
to middle

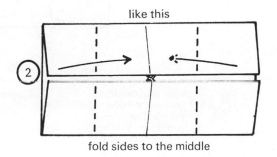

like this

fold sides to the middle

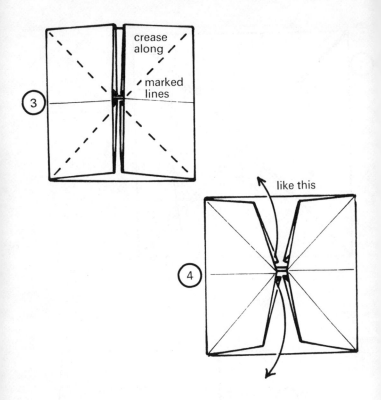

crease along marked lines

like this

now pull out the two arrowed points, the creases will guide you and they will fall into place as in fig. 5

72

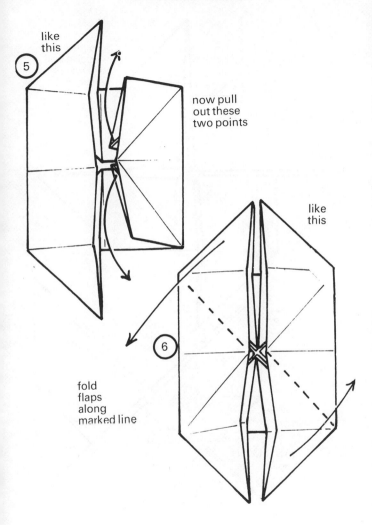

like
this

⑤

now pull
out these
two points

like
this

⑥

fold
flaps
along
marked line

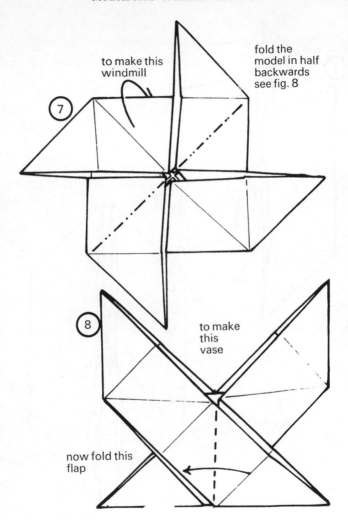

to make this
windmill

fold the
model in half
backwards
see fig. 8

⑦

to make
this
vase

⑧

now fold this
flap

74

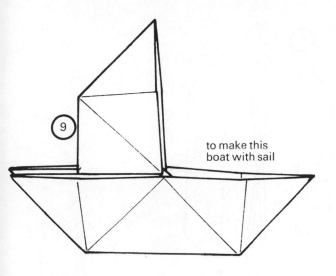

⑨

to make this
boat with sail

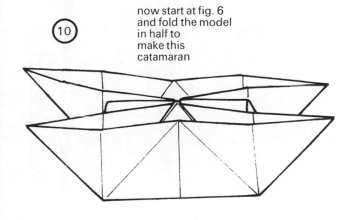

now start at fig. 6
and fold the model
in half to
make this
catamaran

⑩

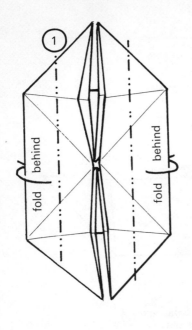

1

fold behind

fold behind

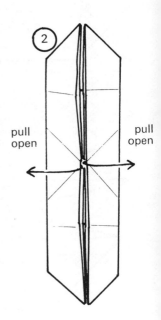

2

pull open

pull open

76

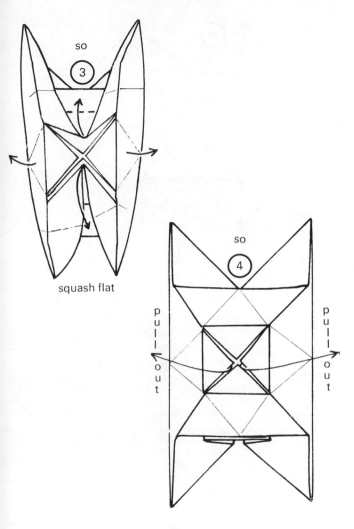

so

3

squash flat

so

4

pull out

pull out

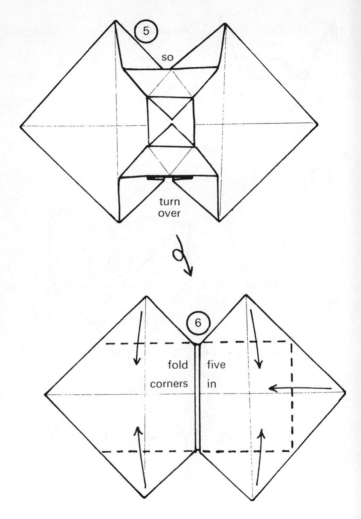

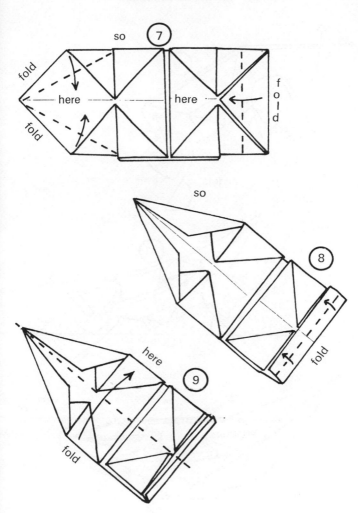

so ⑦

fold here fold here fold

so ⑧ fold

here ⑨ fold

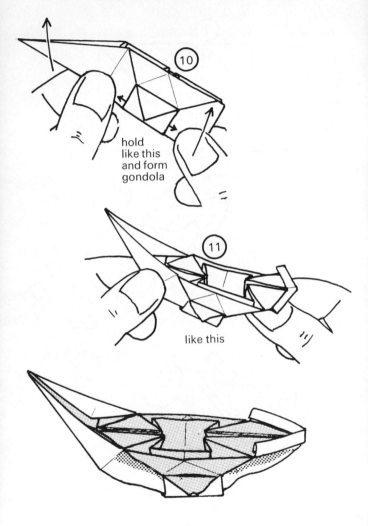

10

hold
like this
and form
gondola

11

like this

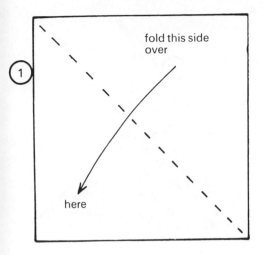

fold this side
over

here

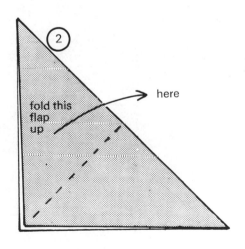

here

fold this
flap
up

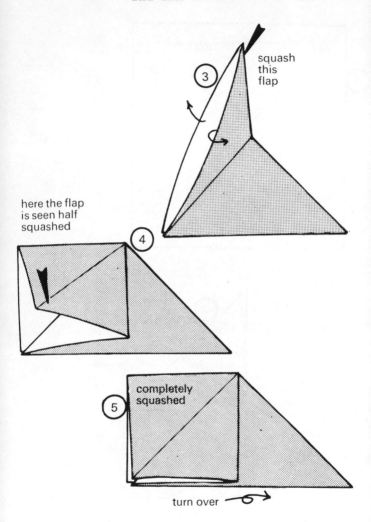

③ squash this flap

④ here the flap is seen half squashed

⑤ completely squashed

turn over

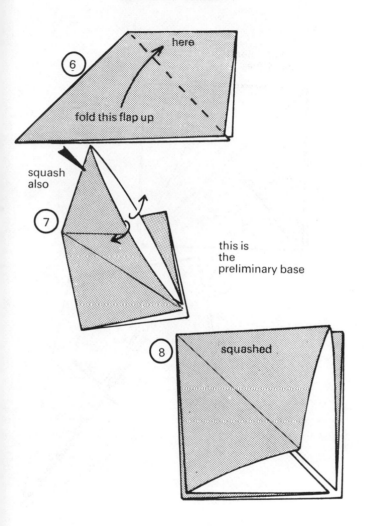

6 fold this flap up / here

squash also

7

this is the preliminary base

8 squashed

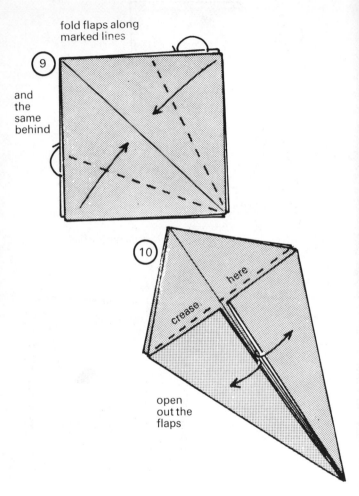

fold flaps along
marked lines

and
the
same
behind

open
out the
flaps

84

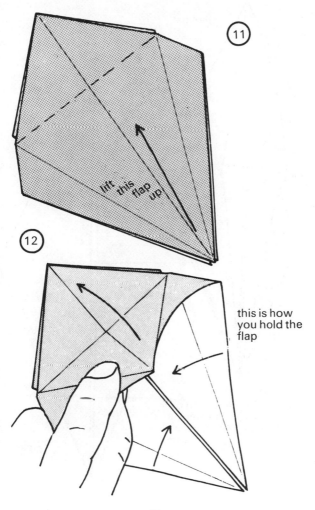

(11) lift this flap up

(12)

this is how
you hold the
flap

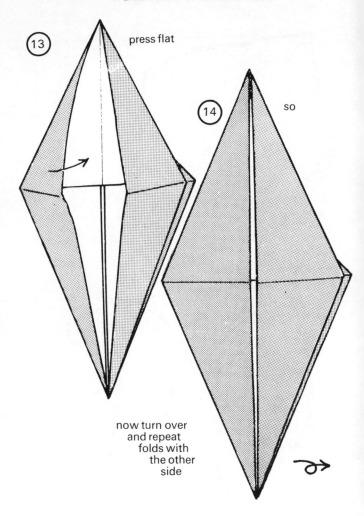

(13) press flat

(14) so

now turn over
and repeat
folds with
the other
side

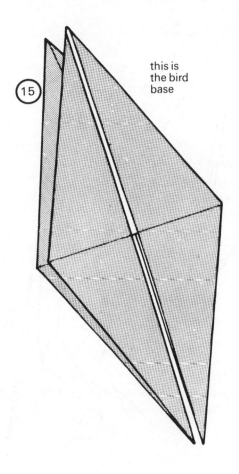

this is
the bird
base

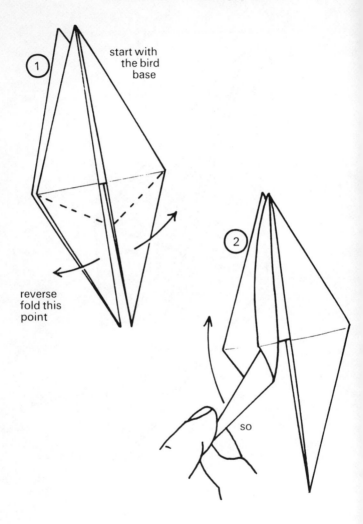

start with
the bird
base

①

reverse
fold this
point

②

so

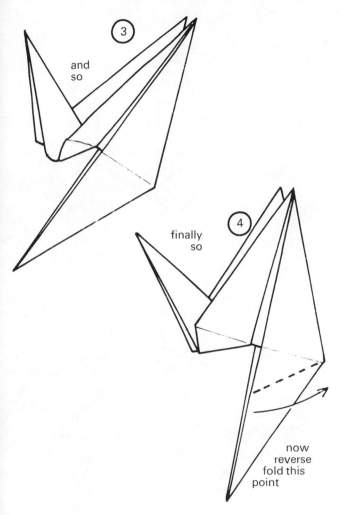

③ and so

④ finally so

now reverse fold this point

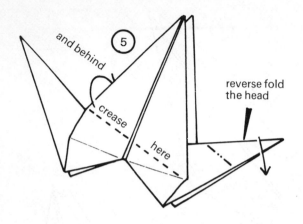

⑤ and behind

crease

here

reverse fold
the head

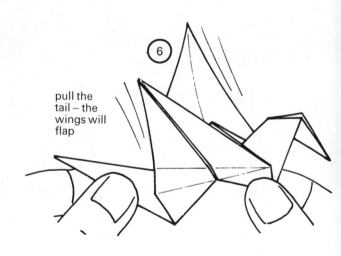

⑥

pull the
tail – the
wings will
flap

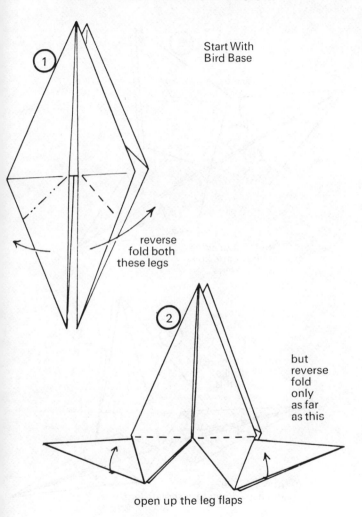

Start With
Bird Base

① reverse
fold both
these legs

② but
reverse
fold
only
as far
as this

open up the leg flaps

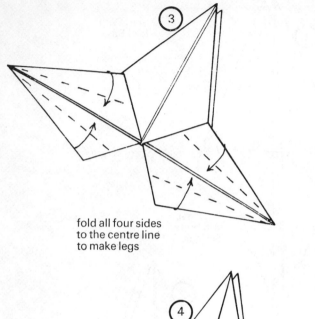

fold all four sides
to the centre line
to make legs

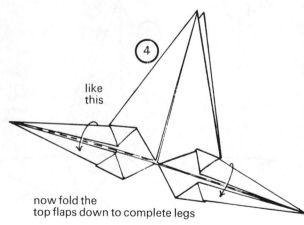

like
this

now fold the
top flaps down to complete legs

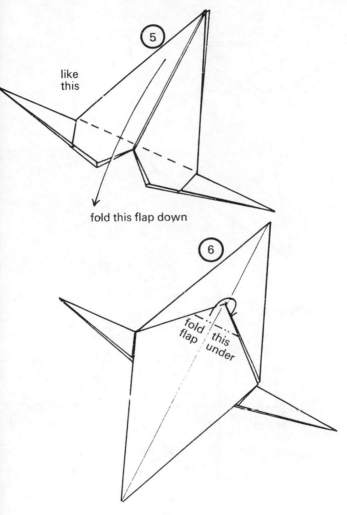

like
this

fold this flap down

fold this
flap under

93

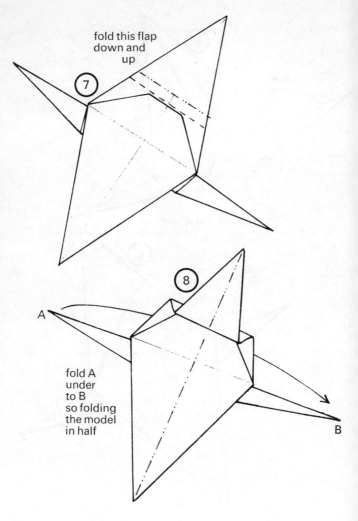

fold this flap
down and
up

⑦

⑧

A

fold A
under
to B
so folding
the model
in half

B

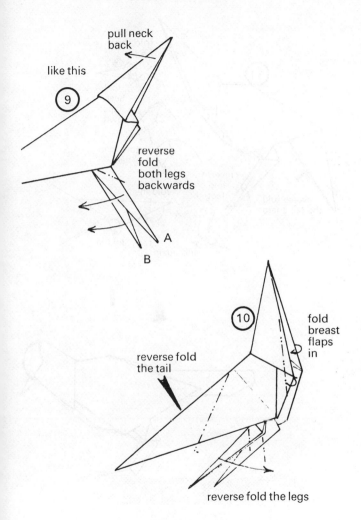

pull neck
back

like this

(9)

reverse
fold
both legs
backwards

A

B

(10)

fold
breast
flaps
in

reverse fold
the tail

reverse fold the legs

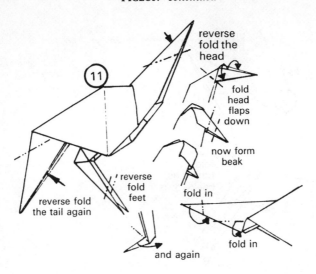

reverse fold the head

fold head flaps down

now form beak

fold in

fold in

reverse fold the tail again

reverse fold feet

and again

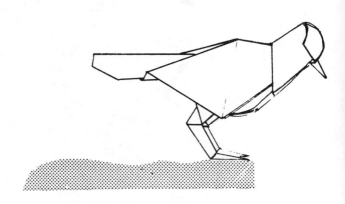

PRAYING MOOR *Spanish Origin. Start with Bird Base*

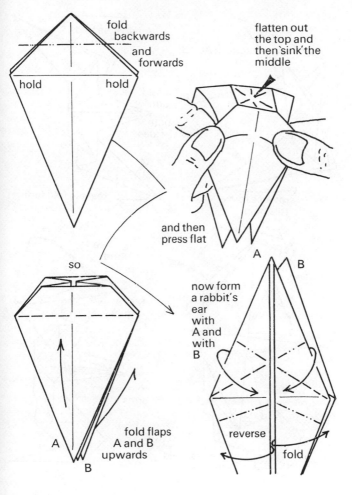

fold
backwards
and
forwards

hold hold

flatten out
the top and
then 'sink' the
middle

and then
press flat

A B

so

now form
a rabbit's
ear
with
A and
with
B

A B

fold flaps
A and B
upwards

reverse fold

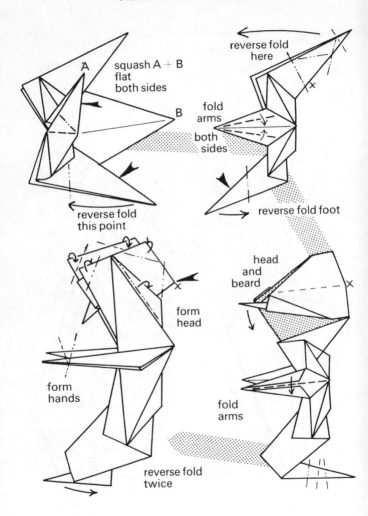

squash A + B
flat
both sides

fold
arms
both
sides

reverse fold
this point

reverse fold
here

reverse fold foot

form head

form hands

reverse fold
twice

head
and
beard

fold
arms

98

THE PRAYING MOOR
COMPLETED

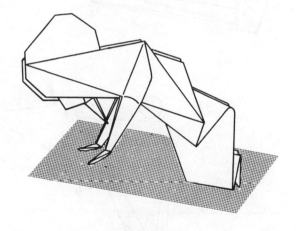

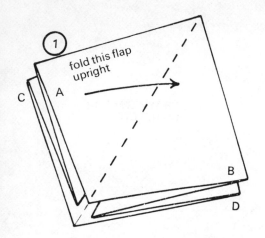

fold this flap
upright

C

A

B

D

1

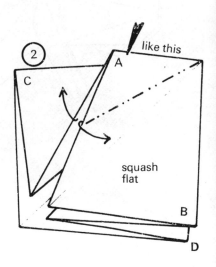

2

C

A

like this

squash
flat

B

D

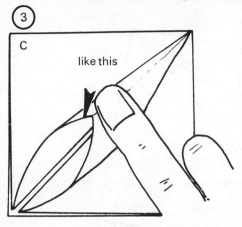

like this

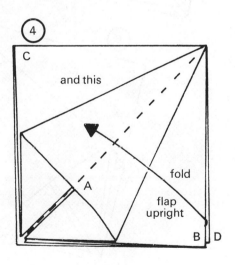

and this

fold

flap
upright

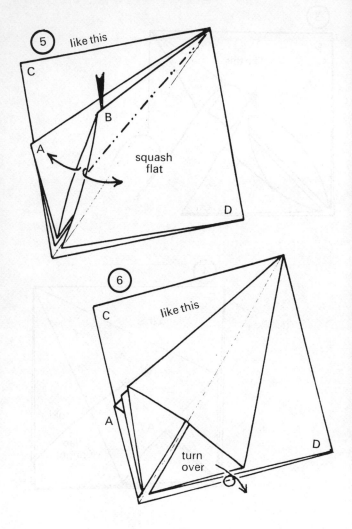

5 like this

C

B

A

squash
flat

D

6 like this

C

A

D

turn
over

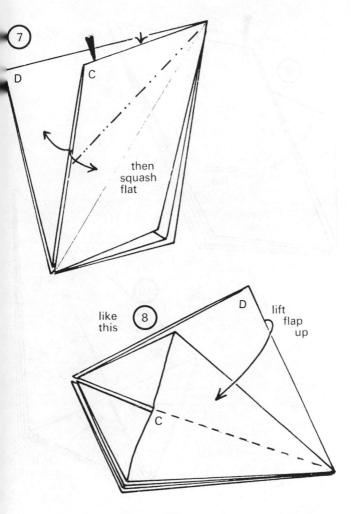

7

D C

then
squash
flat

8

like
this

D

lift
flap
up

C

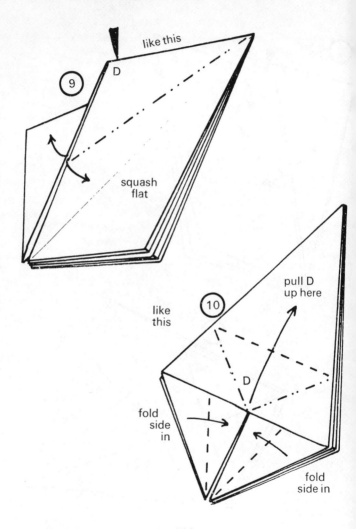

like this

D

⑨

squash
flat

like
this

⑩

pull D
up here

D

fold
side
in

fold
side in

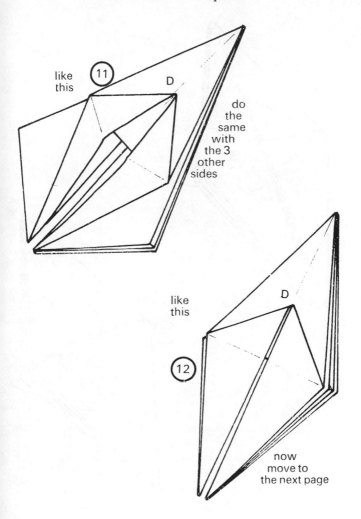

like
this

11

D

do
the
same
with
the 3
other
sides

like
this

D

12

now
move to
the next page

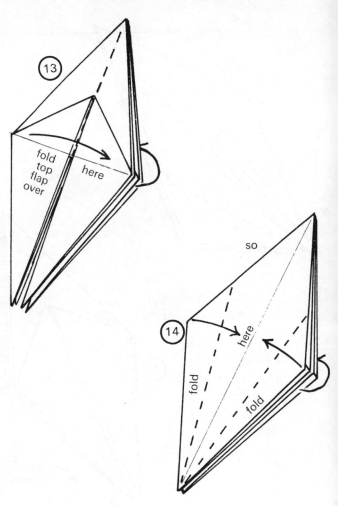

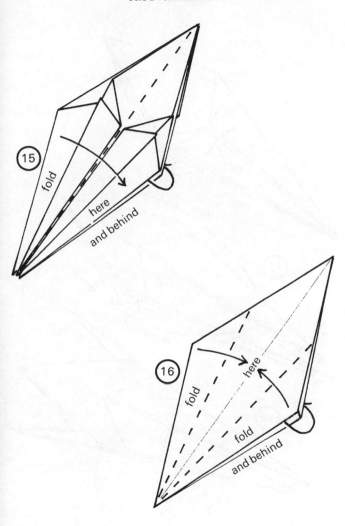

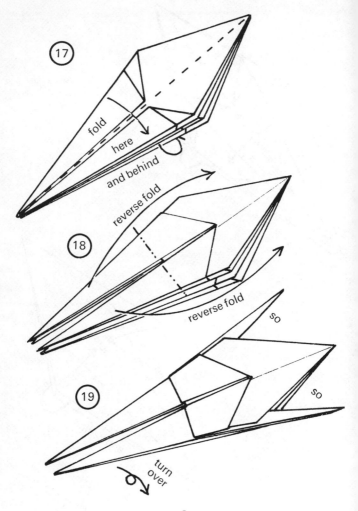

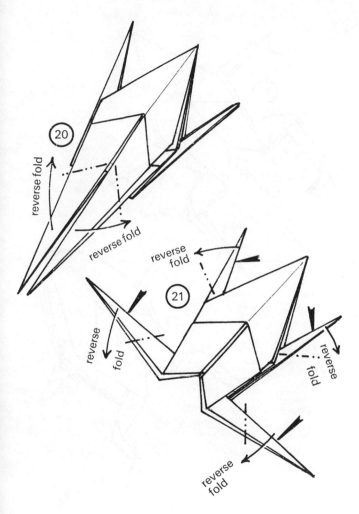

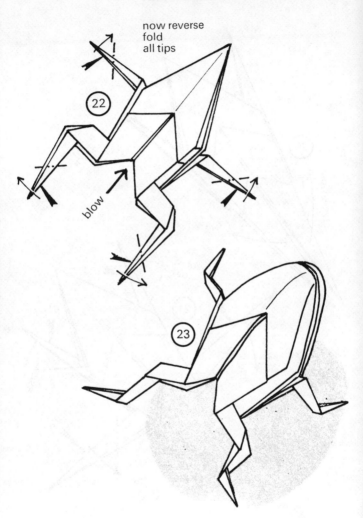

now reverse
fold
all tips

22

blow

23

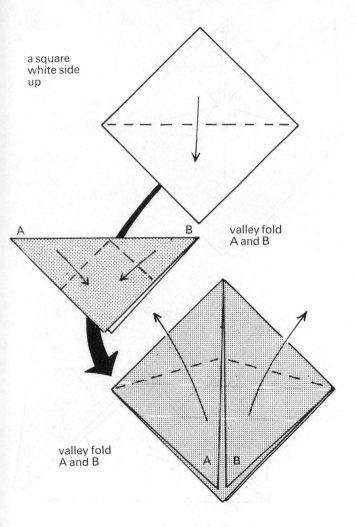

a square
white side
up

valley fold
A and B

valley fold
A and B

III

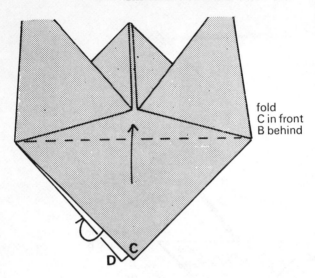

fold
C in front
B behind

C
rabbits' ear

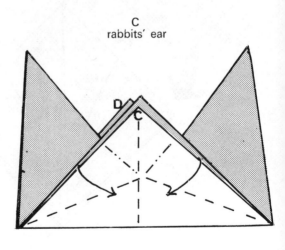

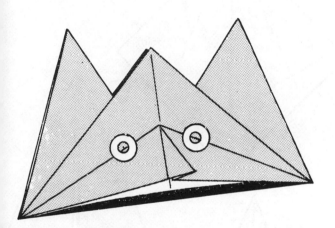

make eyes with gummed eyelets

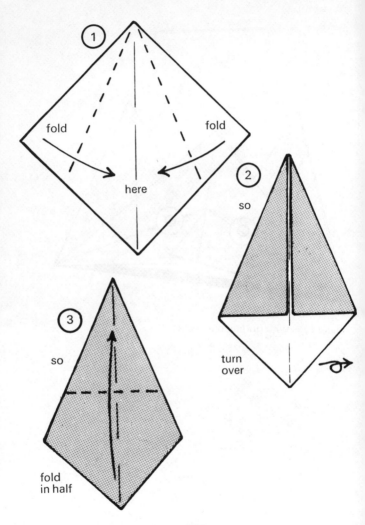

① fold fold
here

② so
turn over

③ so
fold in half

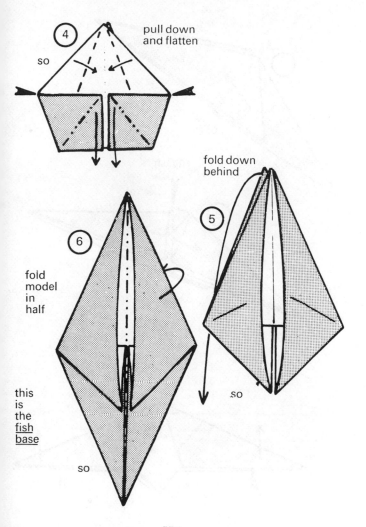

④ so

pull down
and flatten

⑤ fold down
behind

so

⑥ fold
model
in
half

this
is
the
<u>fish</u>
<u>base</u>

so

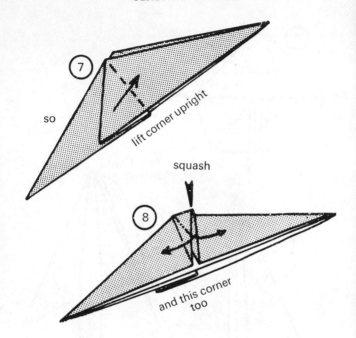

so

lift corner upright

squash

and this corner
too

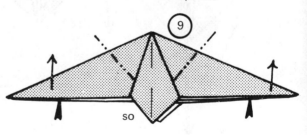

reverse fold
both points

so

116

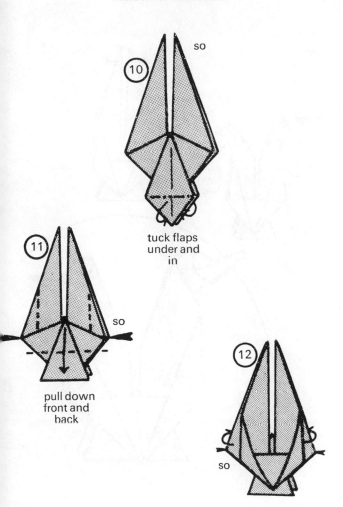

10 so

tuck flaps
under and
in

11 so

pull down
front and
back

12

so

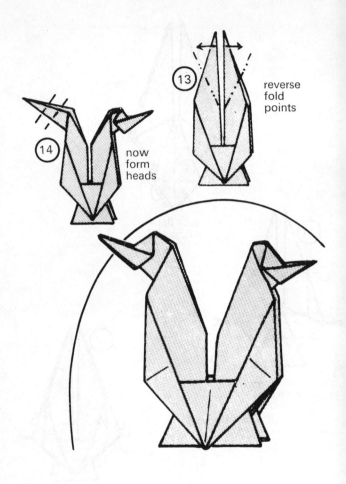

(14) now form heads

(13) reverse fold points

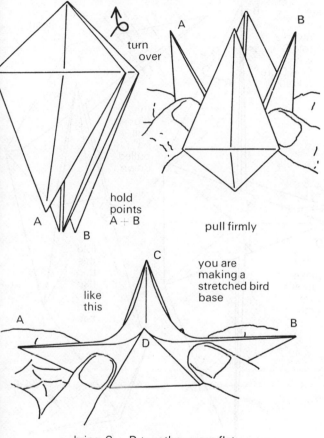

turn
over

hold
points
A + B

pull firmly

like
this

you are
making a
stretched bird
base

bring C – D together press flat

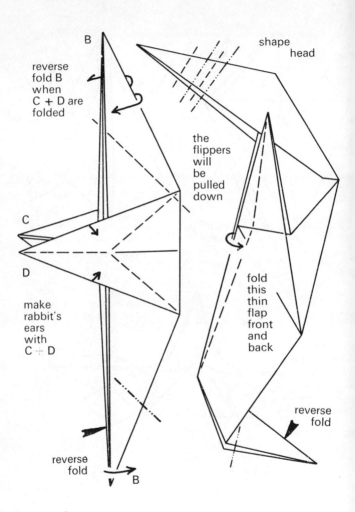

B

reverse
fold B
when
C + D are
folded

shape
head

the
flippers
will
be
pulled
down

C

D

make
rabbit's
ears
with
C + D

fold
this
thin
flap
front
and
back

reverse
fold

reverse
fold

reverse
fold

B

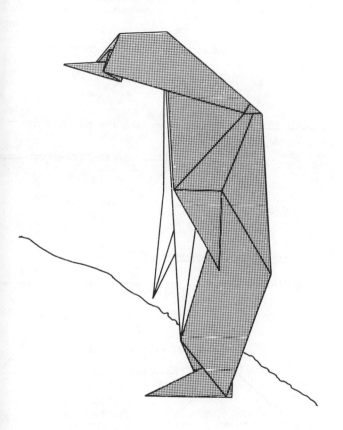

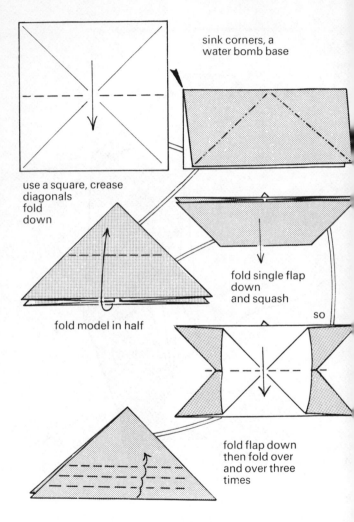

sink corners, a
water bomb base

use a square, crease
diagonals
fold
down

fold single flap
down
and squash

fold model in half

so

fold flap down
then fold over
and over three
times

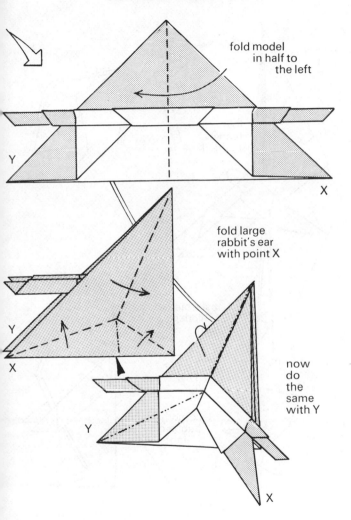

fold model
in half to
the left

fold large
rabbit's ear
with point X

now
do
the
same
with Y

Y

X

Y

X

Y

X

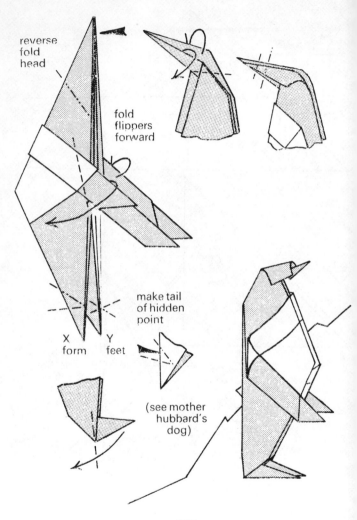

reverse
fold
head

fold
flippers
forward

make tail
of hidden
point

X Y
form feet

(see mother
hubbard's
dog)

124

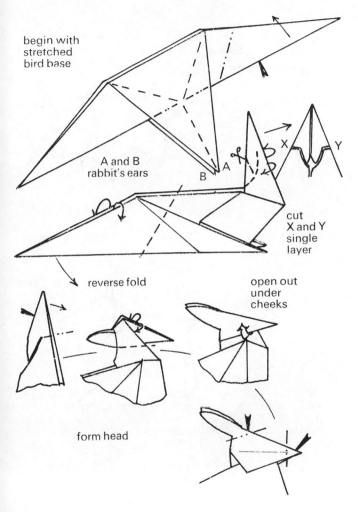

begin with
stretched
bird base

A and B
rabbit's ears

B A

X Y

cut
X and Y
single
layer

reverse fold

open out
under
cheeks

form head

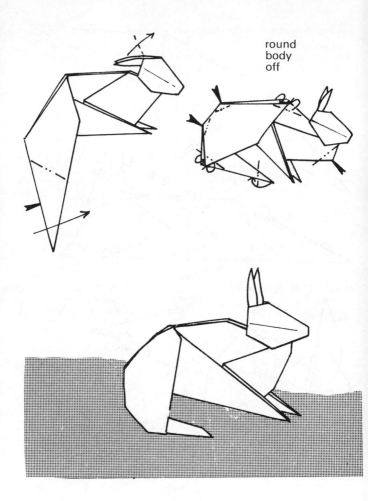

round
body

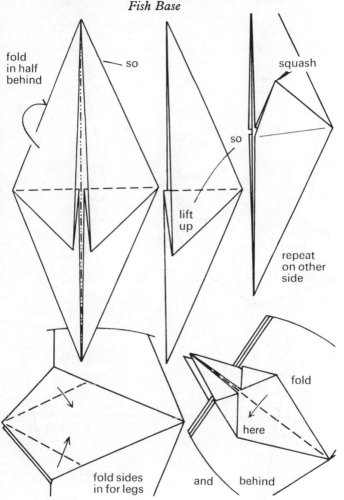

fold
in half
behind

so

squash

so

lift
up

repeat
on other
side

fold

here

fold sides
in for legs

and behind

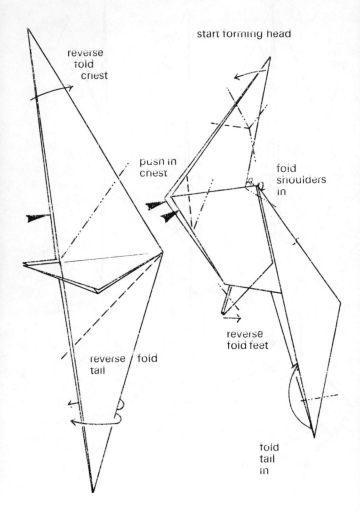

start forming head

reverse
fold
chest

push in
chest

fold
shoulders
in

reverse fold
tail

reverse
fold feet

fold
tail
in

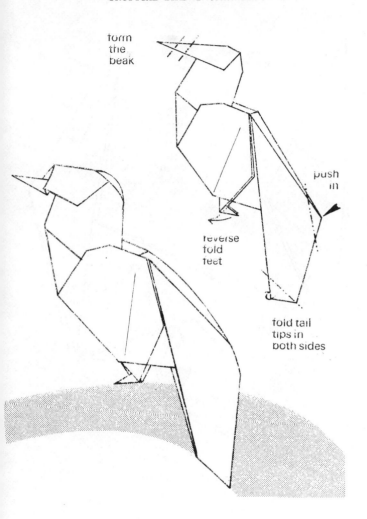

form
the
beak

push
in

reverse
fold
feet

fold tail
tips in
both sides

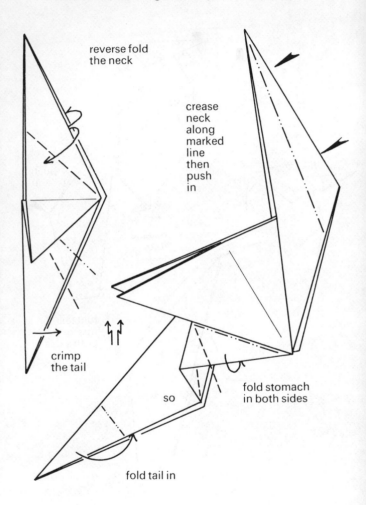

reverse fold
the neck

crease
neck
along
marked
line
then
push
in

crimp
the tail

so

fold stomach
in both sides

fold tail in

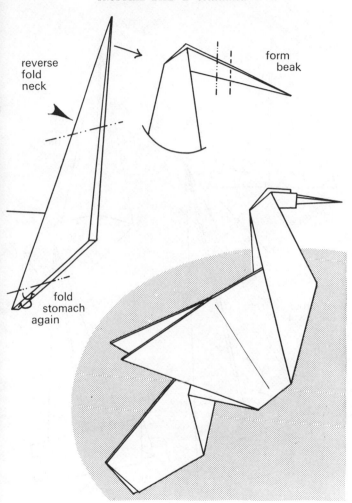

reverse
fold
neck

form
beak

fold
stomach
again

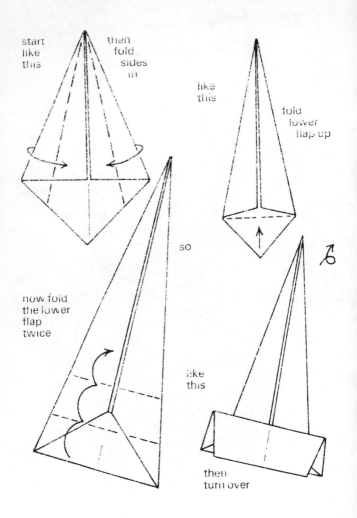

start like this

then fold sides in

like this

fold lower flap up

so

now fold the lower flap twice

like this

then turn over

132

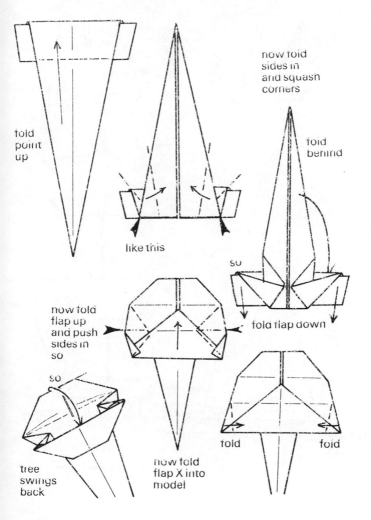

fold
point
up

like this

now fold
sides in
and squash
corners

fold
behind

so

fold flap down

now fold
flap up
and push
sides in
so

so

tree
swings
back

now fold
flap X into
model

fold fold

133

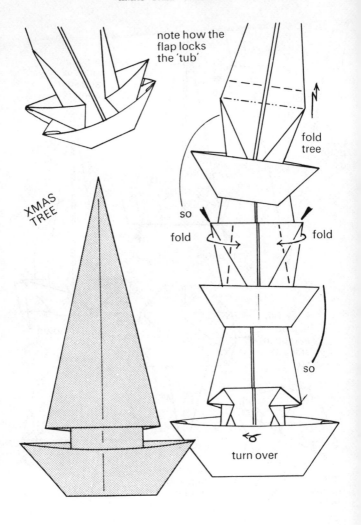

note how the
flap locks
the 'tub'

fold tree

so

fold

fold

so

XMAS
TREE

turn over

134

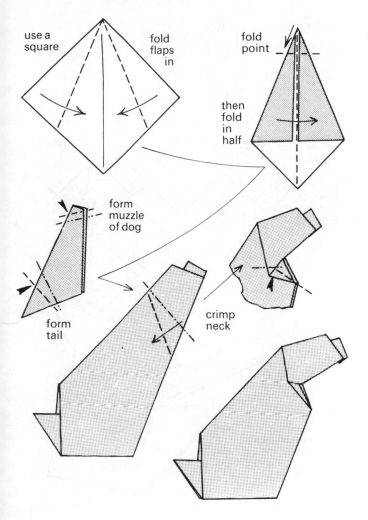

use a square

fold flaps in

fold point

then fold in half

form muzzle of dog

form tail

crimp neck

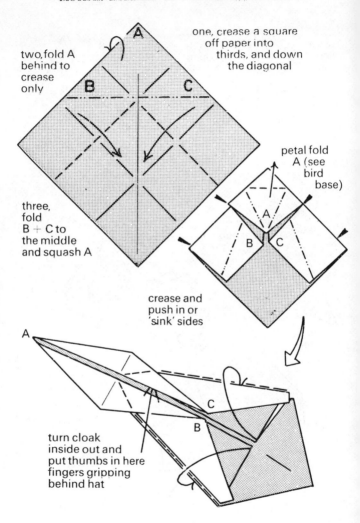

one, crease a square off paper into thirds, and down the diagonal

two, fold A behind to crease only

three, fold B + C to the middle and squash A

petal fold A (see bird base)

crease and push in or 'sink' sides

turn cloak inside out and put thumbs in here fingers gripping behind hat

136

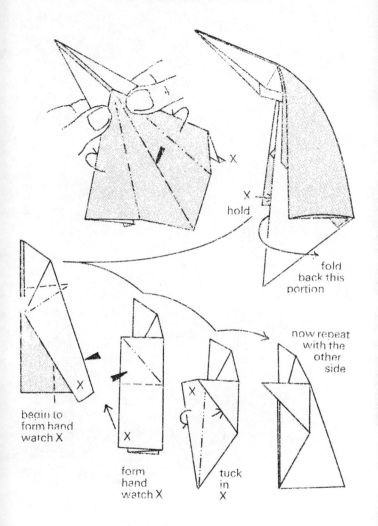

X

X
hold

fold
back this
portion

now repeat
with the
other
side

begin to
form hand
watch X

form
hand
watch X

X

tuck
in
X

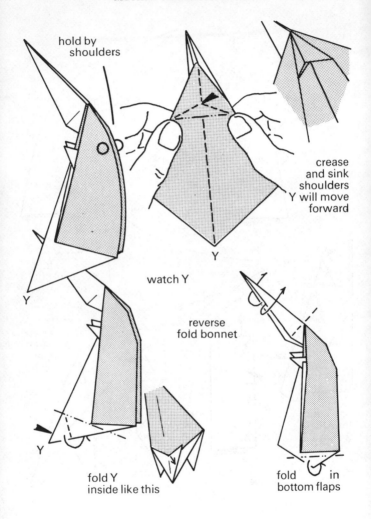

hold by
shoulders

crease
and sink
shoulders
Y will move
forward

watch Y

reverse
fold bonnet

Y

fold Y
inside like this

fold in
bottom flaps

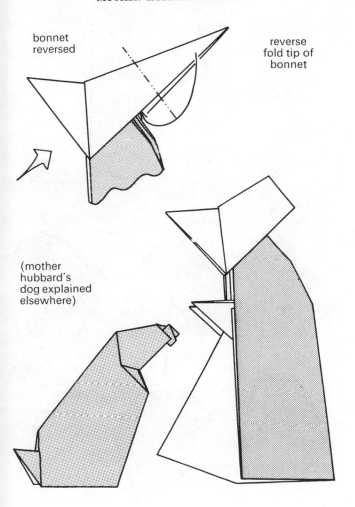

bonnet
reversed

reverse
fold tip of
bonnet

(mother
hubbard's
dog explained
elsewhere)

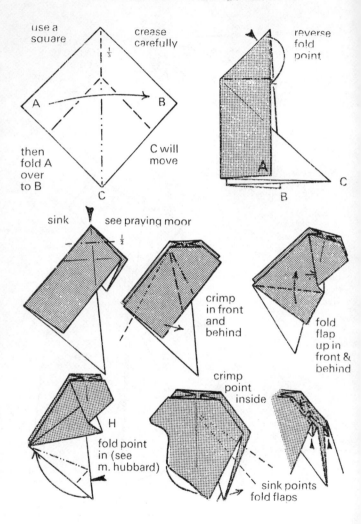

use a square

crease carefully

$\frac{1}{3}$

A → B

then fold A over to B

C will move

reverse fold point

A

C

B

sink see praving moor

$\frac{1}{2}$

crimp in front and behind

fold flap up in front & behind

H

fold point in (see m. hubbard)

crimp point inside

sink points fold flaps

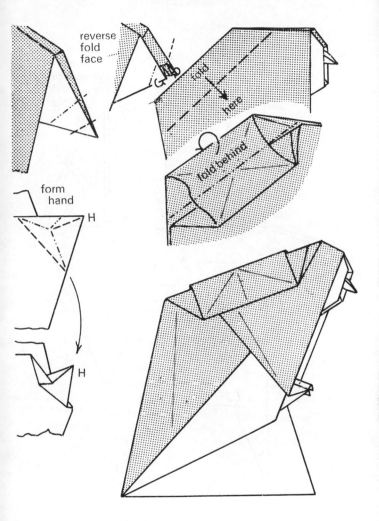

SQUIRREL *Merton H. Wolfman, Liverpool, England*

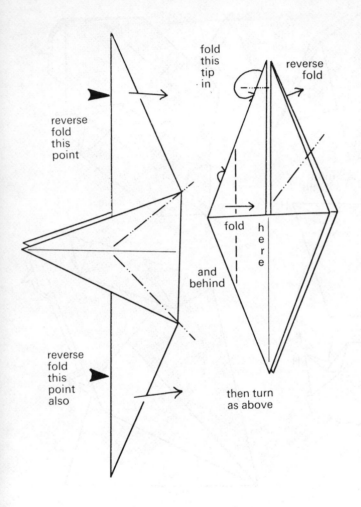

reverse
fold
this
point

fold
this
tip
in

reverse
fold

reverse
fold
this
point
also

fold
here

and
behind

then turn
as above

142

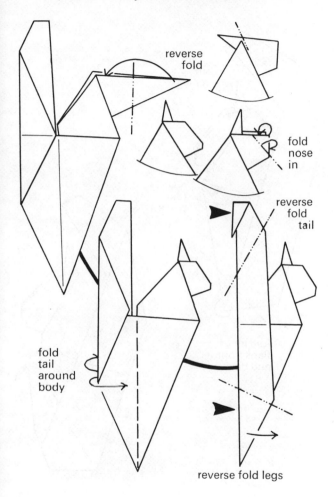

reverse
fold

fold
nose
in

reverse
fold
tail

fold
tail
around
body

reverse fold legs

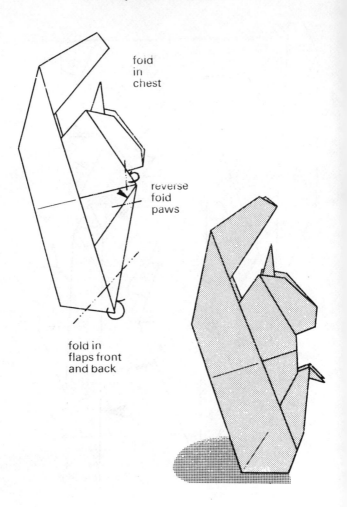

fold
in
chest

reverse
fold
paws

fold in
flaps front
and back

144

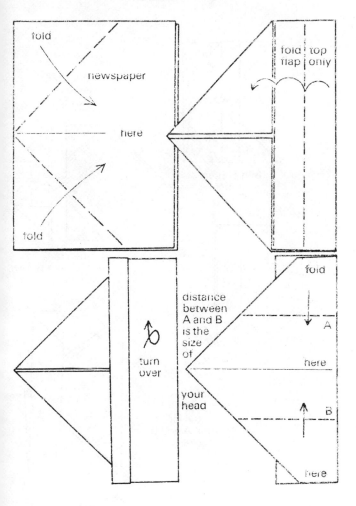

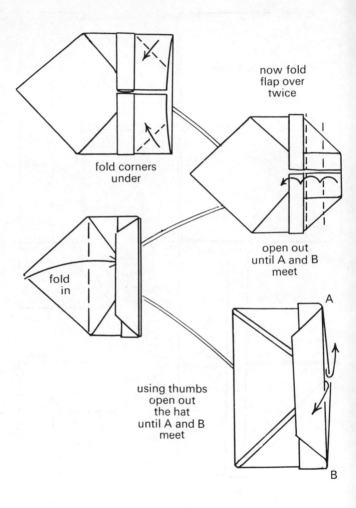

now fold
flap over
twice

fold corners
under

open out
until A and B
meet

fold
in

using thumbs
open out
the hat
until A and B
meet

A

B

146

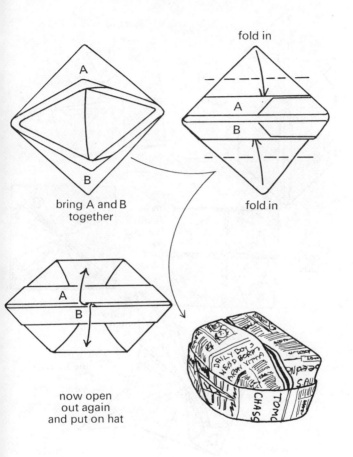

bring A and B
together

fold in

A

B

fold in

A

B

now open
out again
and put on hat

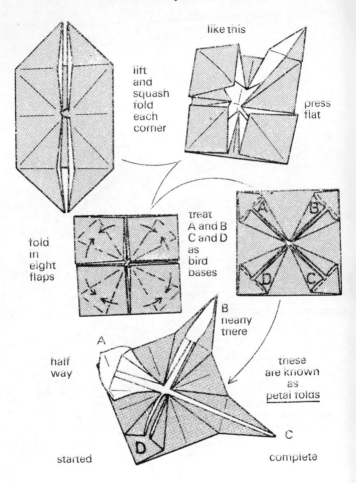

like this

lift
and
squash
fold
each
corner

press
flat

fold
in eight
flaps

treat
A and B
C and D
as
bird
bases

A ——— B

D ——— C

B
nearly
there

A

half
way

these
are known
as
petal folds

D

C

started

complete

148

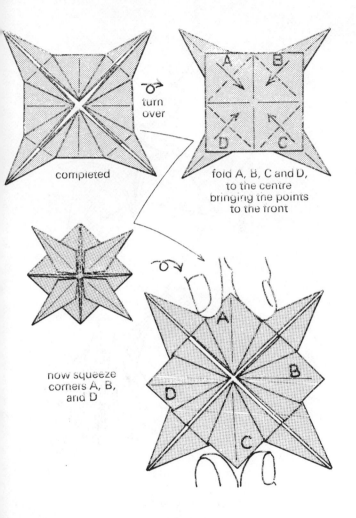

turn over

completed

fold A, B, C and D
to the centre
bringing the points
to the front

now squeeze
corners A, B,
and D

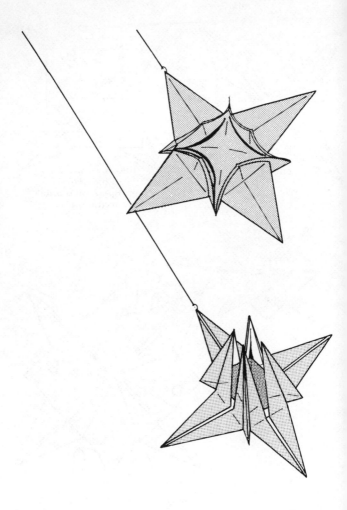

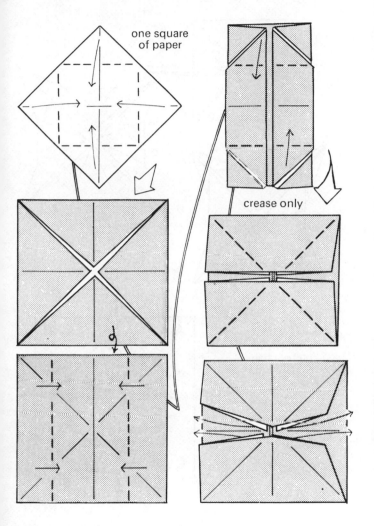

one square
of paper

crease only

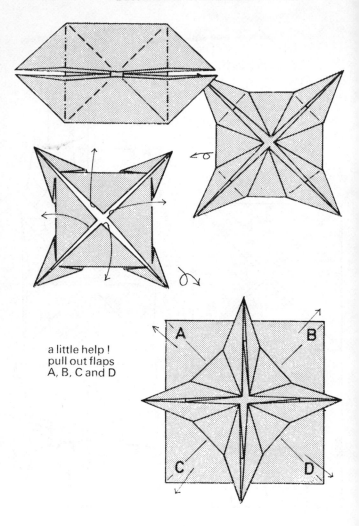

a little help !
pull out flaps
A, B, C and D

A B

C D

152

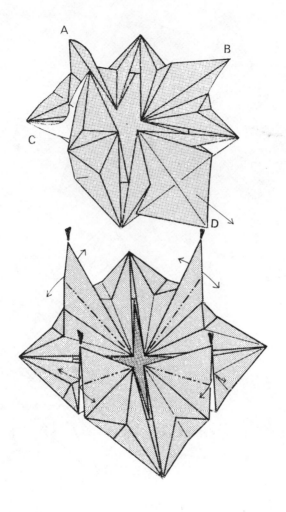

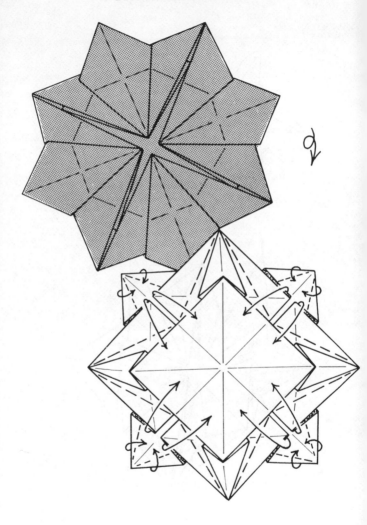

154

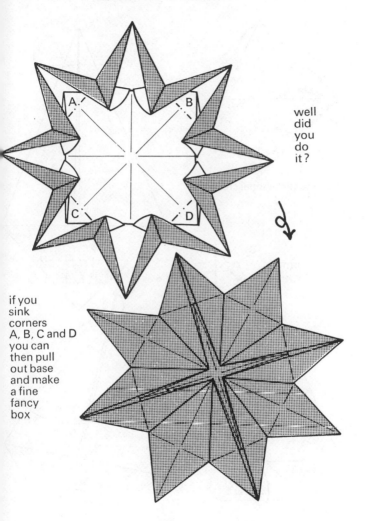

well
did
you
do
it ?

if you
sink
corners
A, B, C and D
you can
then pull
out base
and make
a fine
fancy
box

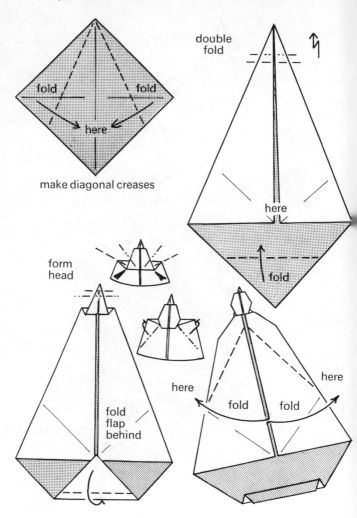

make diagonal creases

double fold

here

fold

form head

fold flap behind

here

fold fold

here

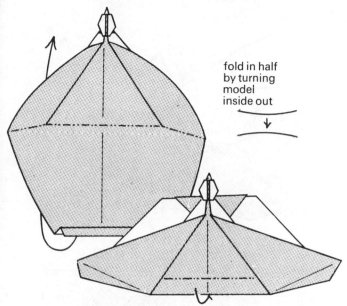

fold in half
by turning
model
inside out

fold along marked line only

when you fold flaps,
A and B will move upwards

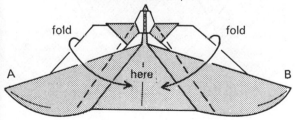

fold fold

A here B

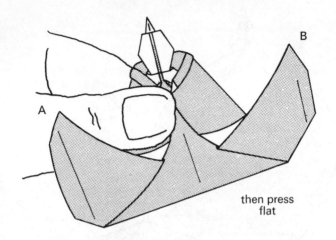

B

A

then press
flat

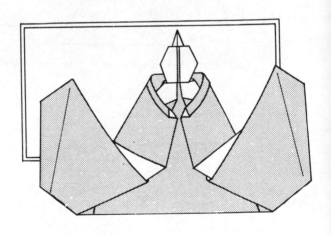

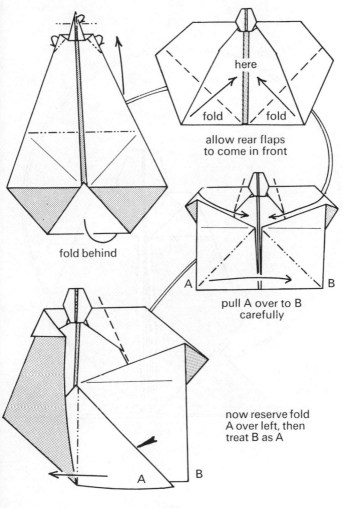

here

fold fold

allow rear flaps
to come in front

fold behind

pull A over to B
carefully

now reserve fold
A over left, then
treat B as A

A B

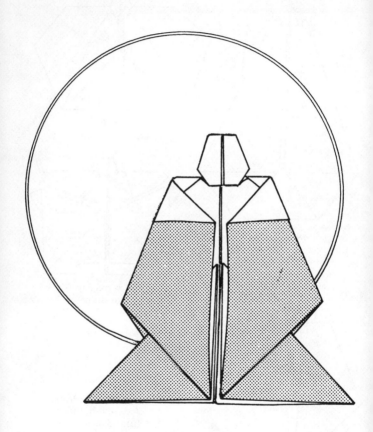

FISH *Samuel Randlett, Illinois, U.S.A.*

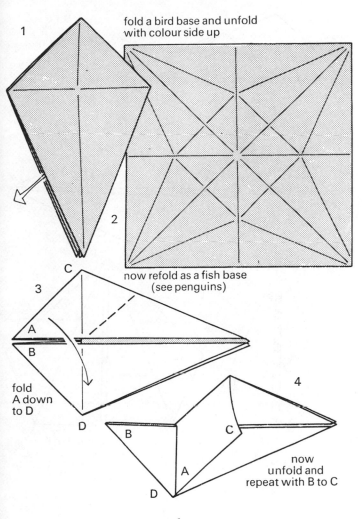

1

fold a bird base and unfold
with colour side up

2

now refold as a fish base
(see penguins)

3

C

A

B

fold
A down
to D

D

4

B

C

A

now
unfold and
repeat with B to C

D

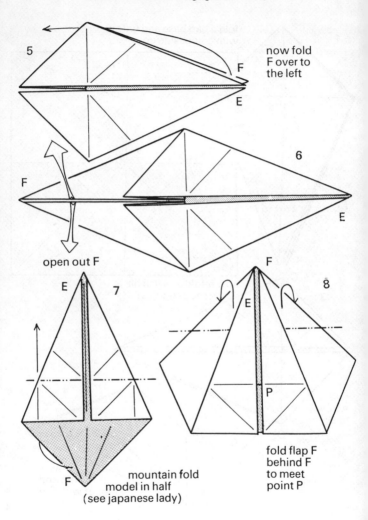

5 now fold F over to the left

F

E

6

F

E

open out F

E

7

mountain fold model in half (see japanese lady)

F

F

8

E

P

fold flap F behind F to meet point P

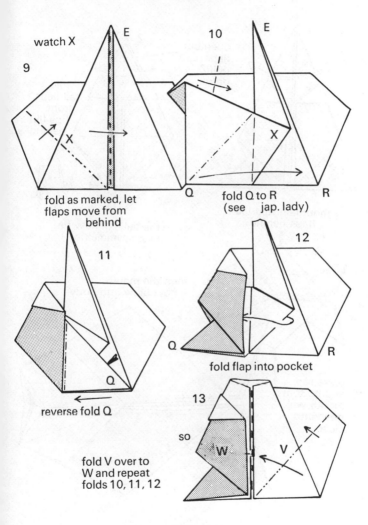

9 watch X

fold as marked, let flaps move from behind

10 fold Q to R (see jap. lady)

11 reverse fold Q

12 fold flap into pocket

13 so fold V over to W and repeat folds 10, 11, 12

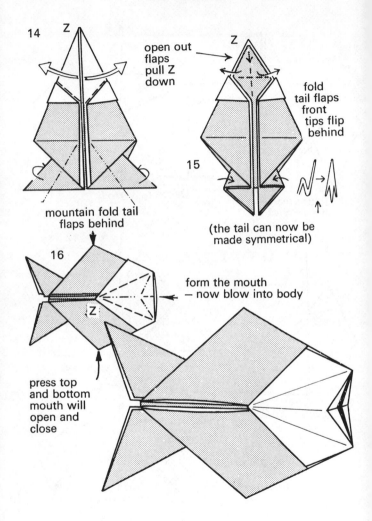

14

Z

open out
flaps
pull Z
down

mountain fold tail
flaps behind

Z

fold
tail flaps
front
tips flip
behind

15

(the tail can now be
made symmetrical)

16

form the mouth
— now blow into body

Z

press top
and bottom
mouth will
open and
close

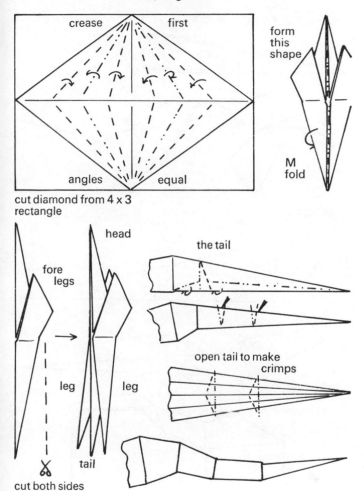

crease first

form
this
shape

angles equal

M
fold

cut diamond from 4 x 3
rectangle

head

fore
legs

the tail

leg leg

open tail to make
crimps

tail

cut both sides
of middle for legs

the head and neck

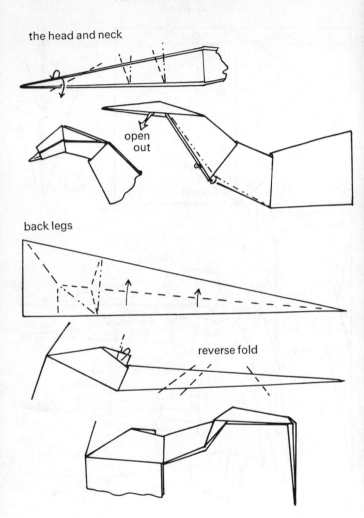

open out

back legs

reverse fold

fore legs

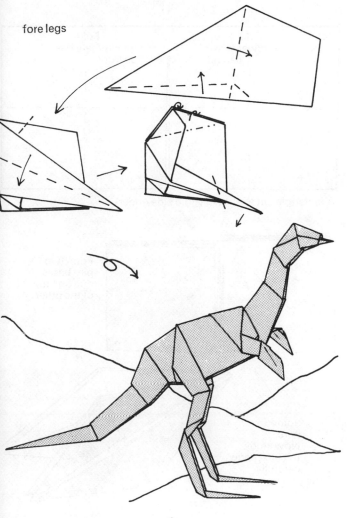

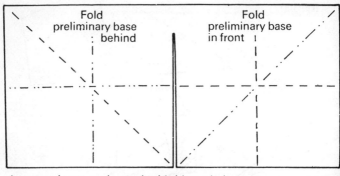

| Fold preliminary base behind | Fold preliminary base in front |

A rectangle cut as shown (gold side under)

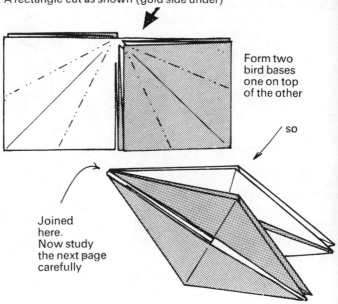

Form two bird bases one on top of the other

so

Joined here. Now study the next page carefully

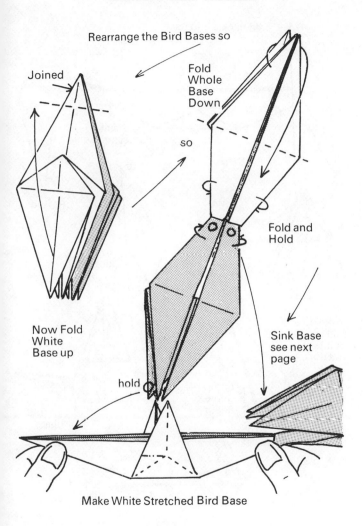

Rearrange the Bird Bases so

Joined

Fold Whole Base Down

so

Now Fold White Base up

Fold and Hold

Sink Base see next page

hold

Make White Stretched Bird Base

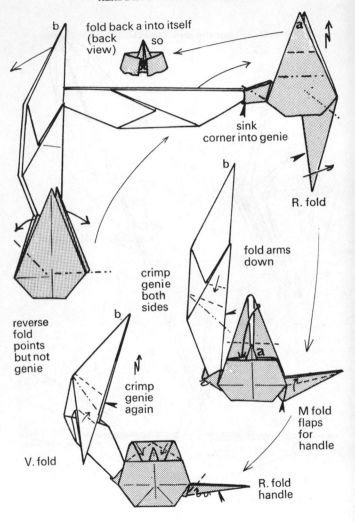

fold back a into itself
(back view)

so

sink corner into genie

R. fold

fold arms down

reverse fold points but not genie

crimp genie both sides

crimp genie again

V. fold

M fold flaps for handle

R. fold handle

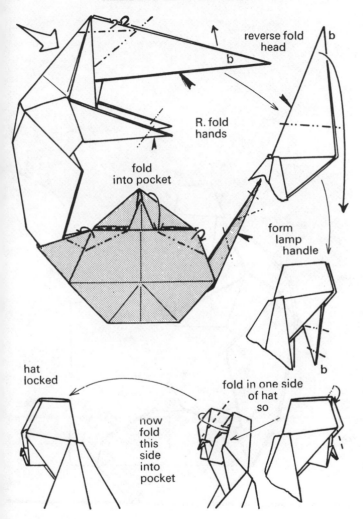

reverse fold head

b

R. fold hands

fold into pocket

form lamp handle

b

hat locked

now fold this side into pocket

fold in one side of hat so

b

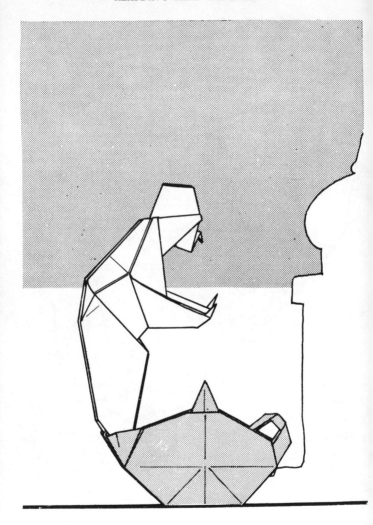

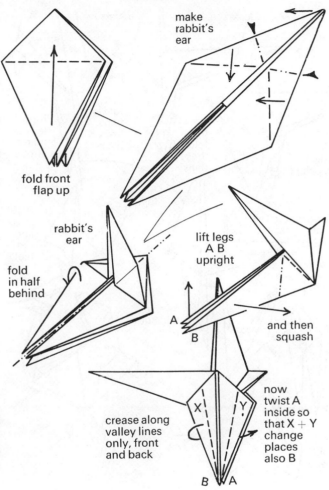

OSTRICH *Robert Harbin, London. Begin with Bird Base*

make rabbit's ear

fold front flap up

rabbit's ear

fold in half behind

lift legs A B upright

A
B

and then squash

now twist A inside so that X + Y change places also B

crease along valley lines only, front and back

X Y

B A

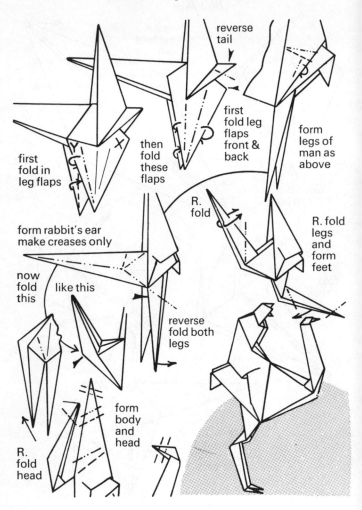

reverse
tail

first fold leg
flaps
front &
back

form
legs of
man as
above

first
fold in
leg flaps

then
fold
these
flaps

R.
fold

R. fold
legs
and
form
feet

form rabbit's ear
make creases only

now
fold
this

like this

reverse
fold both
legs

R.
fold
head

form
body
and
head

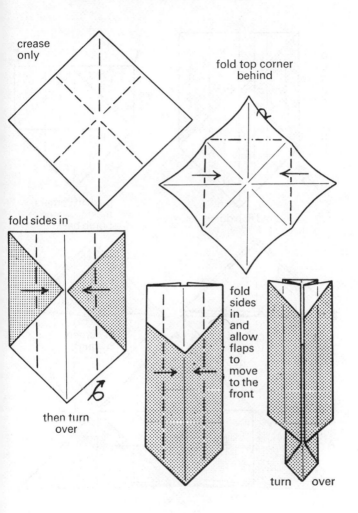

crease only

fold top corner behind

fold sides in

then turn over

fold sides in and allow flaps to move to the front

turn over

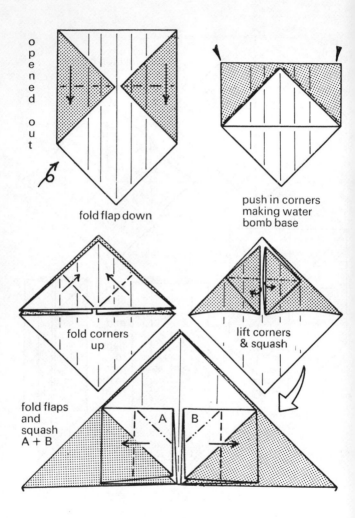

opened out

fold flap down

push in corners
making water
bomb base

fold corners
up

lift corners
& squash

fold flaps
and
squash
A + B

A B

1′ 6

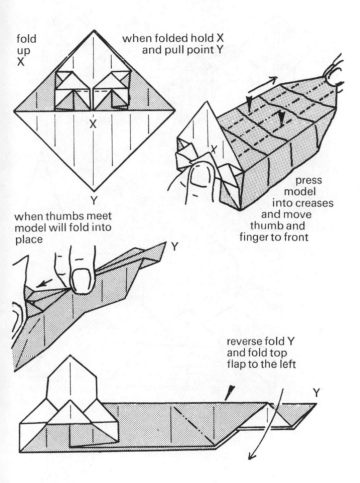

fold
up
X

when folded hold X
and pull point Y

X

Y

when thumbs meet
model will fold into
place

press
model
into creases
and move
thumb and
finger to front

Y

reverse fold Y
and fold top
flap to the left

Y

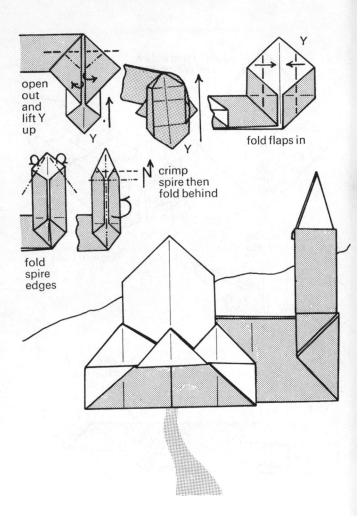

open
out
and
lift Y
up

Y

Y

Y

fold flaps in

crimp
spire then
fold behind

fold
spire
edges

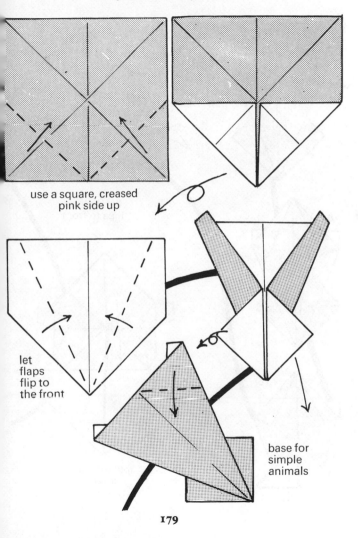

use a square, creased
pink side up

let
flaps
flip to
the front

base for
simple
animals

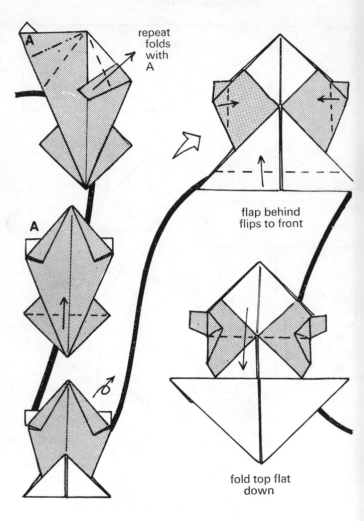

repeat folds with A

flap behind flips to front

fold top flat down

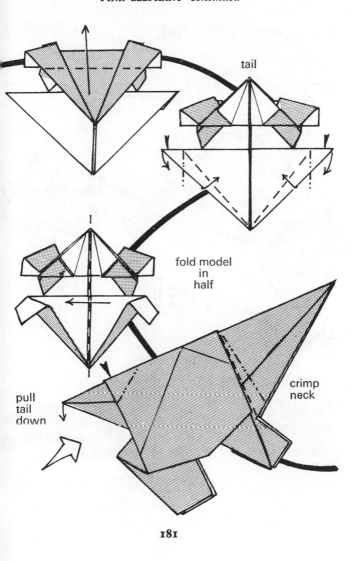

tail

fold model
in
half

crimp
neck

pull
tail
down

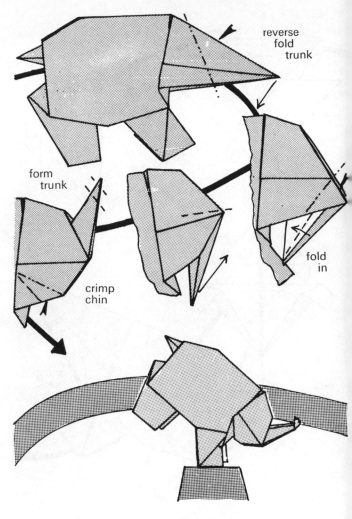

reverse
fold
trunk

form
trunk

fold
in

crimp
chin

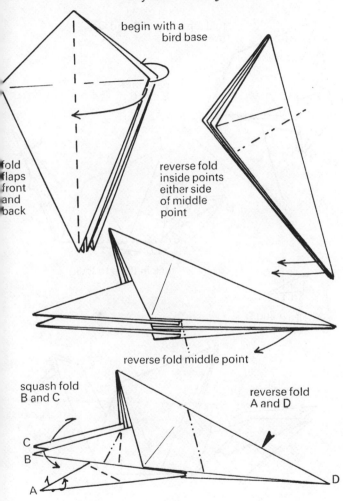

begin with a
bird base

fold
flaps
front
and
back

reverse fold
inside points
either side
of middle
point

reverse fold middle point

squash fold
B and C

reverse fold
A and D

C

B

A

D

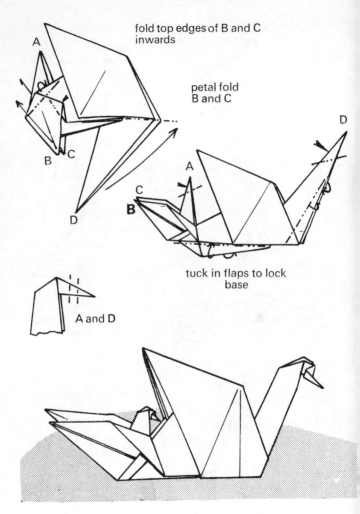

fold top edges of B and C
inwards

petal fold
B and C

tuck in flaps to lock
base

A and D

BIBLIOGRAPHY

Here are the titles of a few books on Origami, which are fairly easy to obtain.

HARBIN, Robert. *Secrets of Origami,* Oldbourne Press, London (1963). One hundred and fifty models are explained by 1,400 drawings and 70 photographs. The standard line-and-arrow code is used. The world's leading folders have contributed original models to this anthology, which also contains a large selection of traditional folds.

— *Paper Magic,* Oldbourne Press, London (1956). This book contains more than a hundred folds, and is ideal for the beginner. Illustrated by Rolf Harris.

RANDLETT, Samuel. *The Art of Origami,* E. P. Dutton Inc., New York (1961).

A really fine book for both beginner and expert. Traditional and original folds are superbly illustrated by Jean Randlett.

— *The Best of Origami; New Models by Contemporary Folders,* E. P. Dutton, Inc., New York (1963). This book is an absolute 'must'. The models are quite outstanding, and the material in this book cannot be found elsewhere. Perfect in every way.

LEWIS, Shari, and OPPENHEIMER, Lillian. *Folding Paper Puppets; Folding Paper Toys,* Stein and Day, New York. Puppets (1962), Toys (1963). Here are two beautifully illustrated books (obtainable almost everywhere) of simple models that work. Splendid for entertaining the young.

YOSHIZAWA, Akira. Books by this author are printed in Japan and can be obtained from The Origami Centre in New York. Printed in Japanese language, but with

detailed illustrations easily understood by the initiated.

HONDA, Isao, Editor, Japan Publications Trading Company Ltd., Central P.O., Box 722, Tokyo, Japan.

Mr. Honda has a great number of books to his credit. They are written in English, and are obtainable almost everywhere.

UCHIYAMA, Okimasa, *Origami Zukan* (Picture Book of Origami), Hikari no Kuni, Tokyo, Japan (1958).

A really fine work on cut and uncut Origami, considered the best book of its kind in Japan. It is not necessary to understand Japanese, as the diagrams and symbols are the standard ones and are sufficiently clear.

SOLORZANO SAGREDO, Vicente, *Papiroflexia Zoomorfica* (2 vols.), Apartado de Correos, 319, Valladolid, Spain.

These two volumes contain 1,000 pages, with more than 3,000 illustrations, many by Ligia Montoya. A knowledge of Spanish is helpful in understanding these books, which are obtainable from the author, price 1,200 pesetas the two.

GIL, Elias Gutierrez, *Papiroflexia*, Logrono: Industrias Graficas, UFA, S.L.

This book is obtainable (price one dollar) from the author, at Instituto Ensenaza Media, Burgos, Spain.

MONTERO, N., *El Mundo de Papel*, Valladolid: Editorian Sever-Cuesta (1939).

Available from the author, at Plaza Campillo 3, Valladolid, Spain, price one dollar.

SALVATELLA, Miguel (editor), *Un Hoja de Papel*.

A fine collection of 80 models in illustrations only. Obtainable from the author, at Santo Domingo 5, Barcelona, Spain, price one dollar.

Most booksellers and big stores seem to stock a few Origami books, and it is a good idea to build up a small library by seeing what one can find in the shops.